H45 034 252 X

D0505433

Please renew/return items by last date
shown. Please call the number below:

Renewals and enquiries: 0300 1234049

Textphone for hearing or
speech impaired users: 01992 555506

www.hertfordshire.gov.uk/libraries Hertfordshire
L32

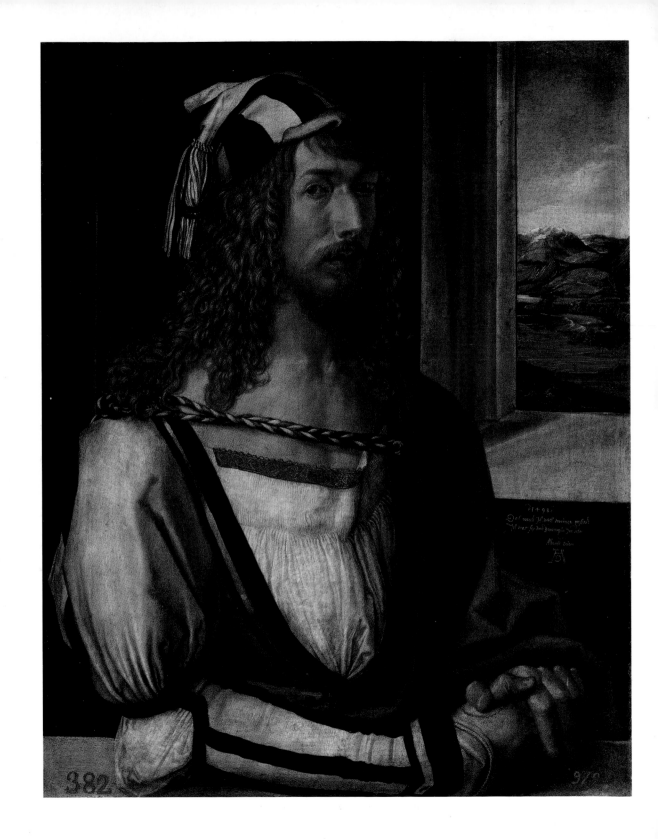

Norbert Wolf

ALBRECHT DÜRER

1471–1528

The genius of the German Renaissance

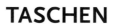

TASCHEN

KÖLN LONDON LOS ANGELES MADRID PARIS TOKYO

FRONT COVER:
Young Venetian Woman, 1505
Mixed media on spruce, 32.5 x 24.5 cm
Vienna, Kunsthistorisches Museum

BACK COVER:
Self-portrait, 1498
Mixed media on limewood, 52 x 41 cm
Madrid, Museo Nacional del Prado

PAGE 1:
Self-portrait with Bandage, 1491/92
Pen and blackish-brown ink, 20.4 x 20.8 cm
Erlangen, Graphische Sammlung der Universität

PAGE 2:
Self-portrait, 1498
Mixed media on limewood, 52 x 41 cm
Madrid, Museo Nacional del Prado

To stay informed about upcoming TASCHEN titles,
please request our magazine at www.taschen.com/magazine or write to
TASCHEN America, 6671 Sunset Boulevard, Suite 1508, USA-Los Angeles, CA 90028,
contact-us@taschen.com, Fax: +1-323-463.4442. We will be happy to send you a free copy
of our magazine which is filled with information about all of our books.

© 2006 TASCHEN GmbH
Hohenzollernring 53, D–50672 Köln
www.taschen.com

Project management: Juliane Steinbrecher, Cologne
Translation: Karen Williams, Rennes-le-Château
Editing: Jon Smale · Schönwälder & Waller, Munich
Layout: Iris Steiner and Anja Dengler · Schönwälder & Waller, Munich
Cover design: Claudia Frey, Cologne
Production: Ute Wachendorf, Cologne

Printed in Germany
ISBN 3–8228–4922–7

Contents

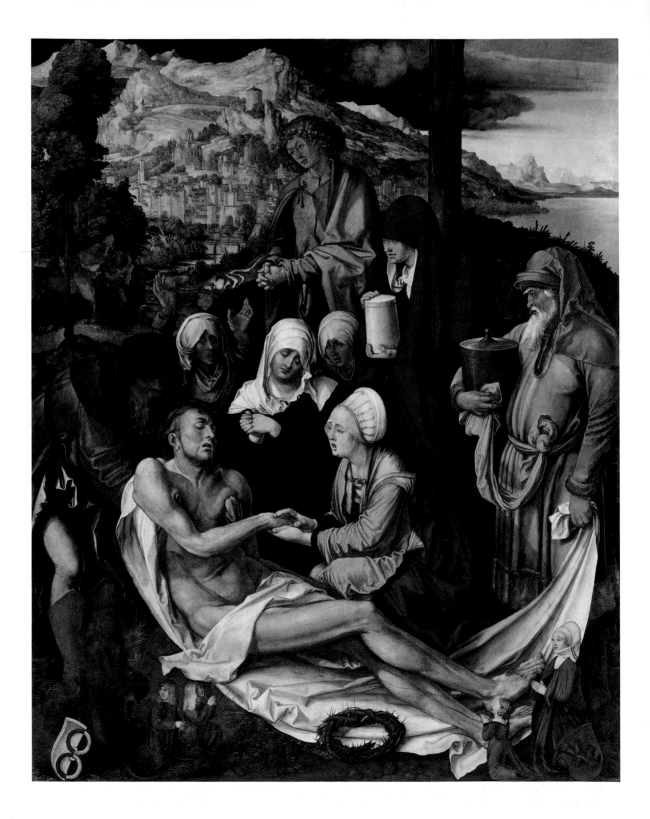

"I was more inclined towards painting"

On 1 April 1988 an inconspicuous visitor walked into the Dürer Room in Munich. Without hesitating, he sprayed sulphuric acid onto three pictures. The acid ate into the surfaces of the *Glim Lamentation* (ill. p. 6), the *Paumgartner Altar* (ill. p. 66/67) and the *Virgin as Mother of Sorrows* (ill. p. 64). The mentally disturbed individual had ruined the paintings seemingly beyond repair. The cost of the damage was later calculated at 35 million Euros. Since then the panels have undergone such thorough restoration that only on close inspection is it possible to see where the original paint has been lost.

Why should a book on Albrecht Dürer begin with a tale of disaster? Because, however paradoxical it may sound, even a catastrophe such as this is proof that the most famous German painter of all time belongs in the pantheon of art history. Attacks in museums only tend to be directed at the works of world-famous artists – prior to Dürer, the same assailant had targeted a painting by Paul Klee in the Hamburg Kunsthalle and three works by Rembrandt in Kassel. Fitting company, in other words, for an artist like Albrecht Dürer. He whom the British Museum in London recently called the "first truly international artist"! The Germans refer to the years around 1500 as the "age of Dürer" and thereby elevate the name of a painter to a synonym for a glittering era.

Dürer was undoubtedly a master of the very highest order, who traced an arc from the Middle Ages to the Renaissance in a manner beyond compare. He was the first German artist to write about his own life; he was the first to grant autonomy to the genre of the self-portrait; he carried the watercolour and the print early on to artistically and technically outstanding heights; he was the first in Germany to draw nudes from life (ill. p. 13); he was the first to underpin his practical œuvre with treatises on artistic theory. Only Leonardo da Vinci bears comparison with him in these achievements – whereby Dürer presented his results considerably more systematically than Leonardo.

His grandiose œuvre contains over 1100 drawings, 34 watercolours, 108 copperplate engravings and etchings, around 246 woodcuts and 188 paintings. New discoveries add to this vast body of work even today: On 8 June 2005 the press stated that a large stained glass window in St Jakob's in Straubing, showing Moses receiving the tablets, is based on a Dürer design.

Even as a thirteen-year-old he was breaking new ground. His silverpoint *Self-portrait* of 1484 (ill. p. 8) represents art history's first drawing by a genuinely

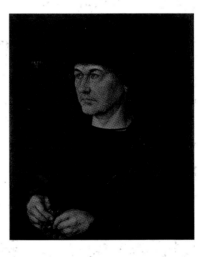

Albrecht Dürer the Elder with Rosary, 1490
Mixed media on panel, 47.5 x 39.5 cm
Florence, Galleria degli Uffizi

The coats of arms of the Dürer and Holper families on the reverse of the panel (ill. p. 93), together with information from written sources, confirm that the present panel was originally accompanied by a pendant, namely a portrait of the artist's mother. From the 17th century onwards this was believed lost, but a few decades ago it was identified as the portrait of a woman in the Germanisches Nationalmuseum in Nuremberg.

Lamentation of Christ, for Albrecht Glim, 1500–1503
Mixed media on softwood, 151 x 121 cm
Munich, Bayerische Staatsgemälde-sammlungen, Alte Pinakothek

Self-portrait aged 13, 1484
Silverpoint on prepared paper, 27.3 x 19.5 cm
Vienna, Graphische Sammlung Albertina

The artist must always have been conscious
of the particular importance of this drawing,
for he kept it in his personal possession and
later wrote in the top right-hand corner: "This
I drew using a mirror; it is my own likeness,
in the year 1484, when I was still a child."

precocious child. Furthermore, if not yet properly part of his early œuvre, it is
at the same time the earliest securely attributed self-portrait by a European
master to have come down to us. That the young draughtsman was still unsure
of his craft is evidenced by certain outlines that have strayed too far, and in the
way in which the tassel of the hat is almost indistinguishable from the boy's hair.
A great deal has been read into the gesture of the pointing finger. The most likely
explanation is simply that the young artist chose a hand gesture commonly
found in religious art: the pointing finger of a prophet or St John pointing to the
Crucified Christ.

This drawing marks the start of the series of fascinating portraits that Dürer
made of himself and his family. To this series belong the panels of his father (ill.
p. 7) and mother (ill. p. 10) of 1490, each turned towards the other in the manner
of a diptych – the portrait of the artist's mother still in the conventional late-

The Artist's Mother, 1514
Charcoal drawing, 42.1 x 30.3 cm
Berlin, Staatliche Museen zu Berlin –
Preussischer Kulturbesitz, Kupferstichkabinett

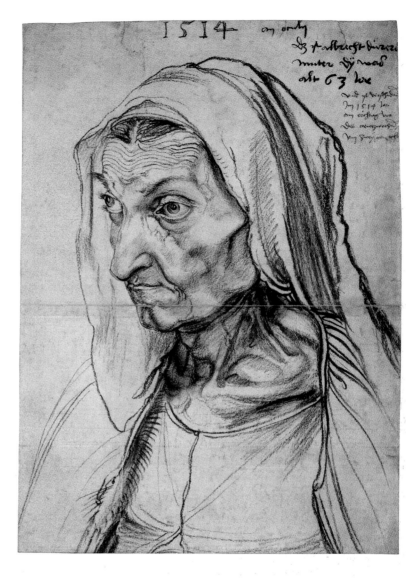

PAGE 10:
Barbara Dürer, née Holper, c. 1489/90
Mixed media on fir, 55.3 x 44.1 cm
Nuremberg, Germanisches Nationalmuseum

PAGE 11:
Portrait of the Artist's Father, 1497
Mixed media on limewood, 51 x 39.7 cm
London, The National Gallery

The theory that Dürer wanted to combine the
present portrait and his own Prado *Self-portrait*
of 1498 into a diptych (the two panels are the
same size) cannot be entirely discounted.

medieval style, which is why its authorship by Dürer was long doubted. In comparison, the London portrait of his father, completed seven years later, shows immense progress (ill. p. 11): the upper body rises like a solid plinth above which the physiognomy and psychology of the pale face are characterised with the greatest sophistication. In the family chronicle that Dürer wrote in 1524, he described his father's life as one of hard work and painstaking effort. Both these and the social standing of Dürer the Elder can be seen in this portrait.

With the study of his 63-year-old mother (ill. p. 9), the son produced the most moving portrait drawing in the history of European art. It was executed on 19 March 1514, just a few weeks before Barbara Dürer's death. She had borne eighteen children, only three of whom outlived her. Hard work and serious illness have ravaged her wasted body. Dürer renders the already dying woman with unsparing realism and thereby elevates her emaciated figure to a spiritual image of transience. When his mother was finally released from her suffering, Albrecht

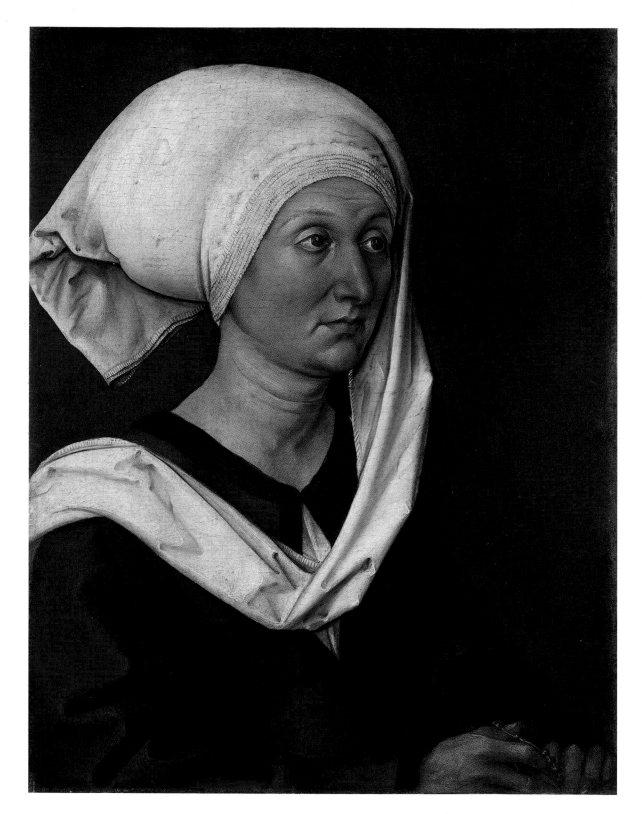

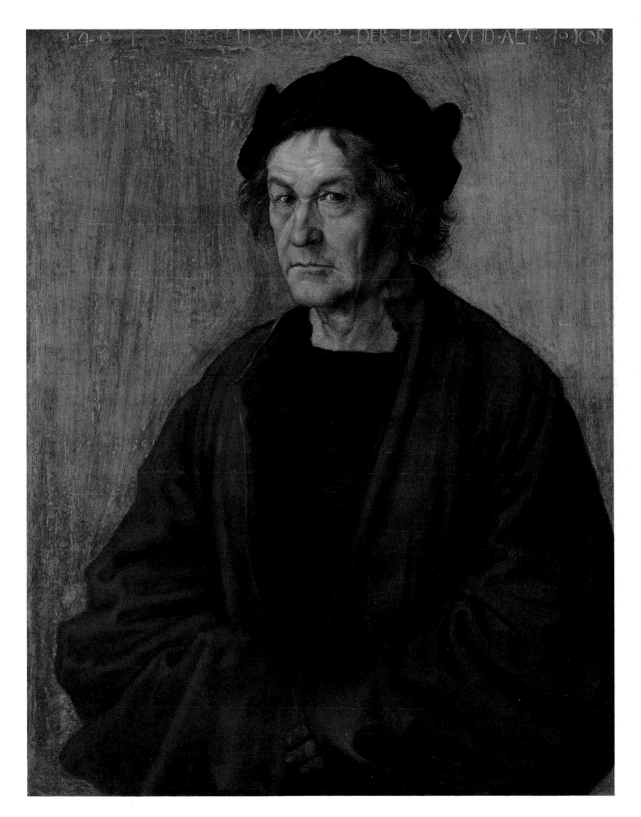

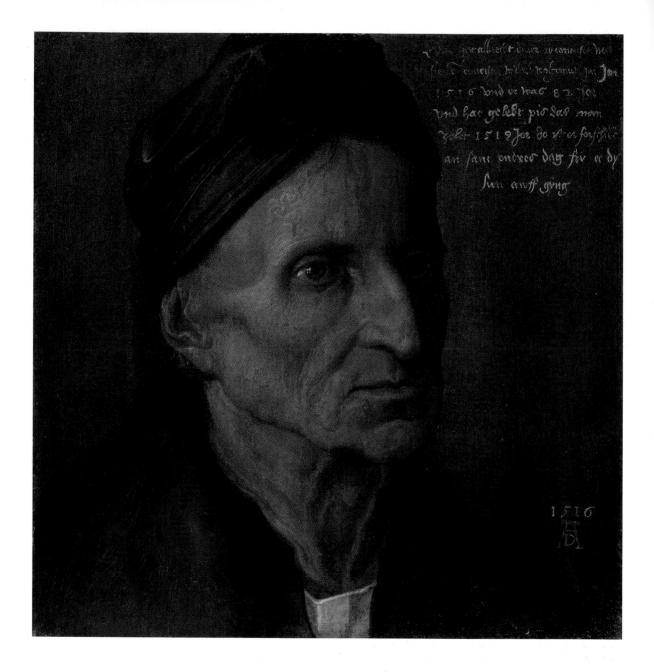

Portrait of Michael Wolgemut, 1516
Mixed media on panel, 29 x 27 cm
Nuremberg, Germanisches Nationalmuseum

Dürer later added to the panel the date on which his
82-year-old former master died, indicating that the portrait
was still in his personal possession at that time.

– with heart-wrenching exactitude – completed the inscription on the sheet with the exact date of her death. He went over the furrowed landscape of her face with a charcoal pencil; in many places the black seems to dissolve into more broken, less coherent structures, through which he lends sympathetic expression to the "weathering" of the ageing sitter.

In its "painterly" consistency, the charcoal portrait of the artist's mother differs radically from the linear precision of the silverpoint drawing by the thirteen-year-old. This latter may be understood as an echo of the metalworking exactness that had belonged to Dürer's apprenticeship as a goldsmith. Let us return to those years.

Dürer's ancestors came from Hungary. Not far from the small town of Gyula lies the village of Ajtós from which the family took its name. In Hungarian, *ajtó* means "door", or "Tür" in German, and "Dürer" therefore means "one born in Ajtós". This link is also referenced in the family coat of arms (ill. p. 93). Dürer's grandfather, Anthoni, broke with the family tradition of horse breeding and cattle rearing to became a goldsmith in Gyula. He later took on his son Albrecht (Dürer's father, 1427 – 1502) as an apprentice.

With the door in the family coat of arms, were the Dürers therefore Hungarians? It is possible. But it is equally possible that they had emigrated from Germany to Hungary centuries before. In fact, the discussion surrounding the nationality of the Dürer family seems somewhat pointless when we consider that the cultural situation in Hungary embraced far more than simply life on the grassy plains of the *puszta*. 15th-century Hungary was namely a nation of many different peoples: apart from the Hungarians themselves, other groups – Croats and Germans, Slovaks and Romanians – also considered "Hungaria" to be their homeland. Countless craftsmen, artists and intellectuals had streamed here from Bohemia, Poland, the Holy Roman Empire and Italy, drawn by the glittering career opportunities offered at the royal court of Matthias Corvinus (1443 – 1490) in Buda and at other major centres. Late-medieval Europe was cosmopolitan in its outlook and lively fluctuations in the strata of society driving production and the economy were nothing unusual.

At the age of seventeen Dürer the Elder moved from Hungary to Nuremberg, where it seems he believed his career prospects would be even better. A document of 1444, which records his presence in the Free Imperial City, also notes that he had previously spent a lengthy period of time perfecting his craft in the Netherlands. His social rise is steady: he is awarded citizenship of Nuremberg and one year later, on 7 July 1468, his master's qualification as a goldsmith. For this he had to be married. He chose his wife well: Barbara Dürer (1452 – 1514), née Holper, also came from a family of goldsmiths.

In 1475 Dürer's father bought a house at the foot of Nuremberg castle, in other words in the best location. From the start of 1486 he also rented premises at the town hall. It may have been here that he won his first imperial commission in 1489. Three years later we find him in Linz, presenting the finished drinking vessels to Frederick III. He writes to his wife telling her proudly about the Emperor's praise.

Named after his father, Albrecht was born on 21 May 1471 as the third child. His parents probably sent him to a school for rudimentary reading, writing and arithmetic. Around 1484 / 85 the boy, now aged about thirteen, became an apprentice in his father's workshop. The concentrated attention to detail, the precision of form engraved in metal that Albrecht learned here and that found expression in the silverpoint drawing discussed earlier, would triumph in the incomparable

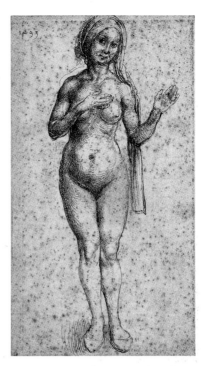

Female Nude (Woman Bathing), 1493
Ink on paper, 27.2 x 14.7 cm
Bayonne, Musée Bonnat

Celestial Body against a Night Sky, c. 1497
Reverse of the *Penitent Saint Jerome* panel in
London

In the Middle Ages, St Jerome was attributed
with the discovery of the "Fifteen Signs" of the
fifteen days leading up to the Last Judgement.
On the Twelfth Day, the stars will fall from the
sky. Dürer's celestial body may be inspired by
this tradition, although the circular yellow form
has also been interpreted as a comet or meteor.

Penitent Saint Jerome, c. 1497
Mixed media on pearwood, 23.1 x 17.4 cm
London, The National Gallery

The saint is kneeling before a crucifix rising
out of the stump of a tree – out of the dead
wood grows the new "tree of life", the Cross.
Beneath the lion on the right, attributed to
the penitent Jerome by legend, appear two
birds, one of them a goldfinch, a conventional
symbol for the Passion of Christ.

artistry of his later graphic works, in particular his copperplate engravings. His
father must first have been proud of the wunderkind in his workshop. But how
did he react when his son broke off his apprenticeship as a goldsmith? "I was
more inclined towards painting", the long-since famous artist would later recall
with elegant concision. The young man's decision may well have been backed up
by his godfather, Anton Koberger (c. 1445 – 1513).

Koberger, himself originally also a goldsmith, ran the biggest and most
modern printing works in Europe. Based in Nuremberg, he also had subsidiaries
in Basle, Cracow, Lyons, Paris, Strasburg, Venice and Vienna. He was also in-
volved in publishing and commissioning woodcuts for international book pro-
jects. At the end of the 15th century, around 100 journeymen were working at his
reputedly 24 printing presses.

Once the die was cast in favour of a career as an artist, Dürer senior – in for a
penny, in for a pound – dispatched his son to Nuremberg's most highly regarded
and commercially successful atelier, run by Michael Wolgemut (1433/34 or
1437 – 1519; ill. p. 12). Wolgemut's workshop was a large-scale enterprise whose
repertoire embraced virtually every artistic technique: woodcut illustrations for
books, designs for handicraft and stained glass, and – in the sphere of painting –
not only altarpieces, the chief objects of demand, but also portraits and secular
subjects. Stylistically speaking, the workshop offered a Franconian version of the
art of the great Netherlandish masters – technically solid, not uninspired, with a
simple naturalism of an average standard.

As was the custom, the young painter and graphic artist furthered his training
through travel. Dürer set off in April 1490. We can only speculate about the route
he took. He probably travelled first to Frankfurt am Main, the great trade fair
centre. Dürer may also have visited Mainz, the birthplace of modern printing. At
all events, the influence of various Middle-Rhenish masters can be demonstrated
in his later prints. Carel van Mander records in his *Schilder-Boeck* (1604) that
Dürer went to the Netherlands, as does Joachim von Sandrart (1606– 1688) in his
Teutsche Academie (1675). There has been a recent attempt to reconstruct a visit
by the young artist to the Bruges workshop of Hans Memling (d. 1494) – but this
is unconvincing.

Certain, however, is Dürer's final destination: Colmar in the Alsace and
the workshop of Martin Schongauer (c. 1450 – 1491), the celebrated Upper Ger-
man painter who had absorbed so much of Early Netherlandish art. When
Dürer arrived in 1492, however, it was to find that the master had just died.
He therefore continued on to the printing centre of Basle, where – as a journey-
man – he was immediately engaged to execute woodcuts for major projects:
amongst other things, he supplied numerous – artistically not yet convincing –
illustrations for *The Ship of Fools,* the literary bestseller by Sebastian Brant pub-
lished in Basle in 1494.

In May 1494 Dürer was back in Nuremberg. During his absence, his father
had chosen a bride for him. On 7 July he married the 19-year-old Agnes Frey
(1475 – 1539). Her father, Hans Frey (c. 1450 – 1523) was a wrought-ironworker
and mechanic. His new mother-in-law, Anna Rummel (d. 1521) was a member
of one of Nuremberg's ruling families, and so Dürer had thus married into the
patriciate. The advantages this offered appear to have been the main grounds
for the marriage. It was probably not a love match, because the young Dürer
then set off on another trip just a few weeks after the wedding. He was also
fleeing from the plague, which had broken out in Nuremberg in 1494, and this
time Dürer was being drawn to Italy.

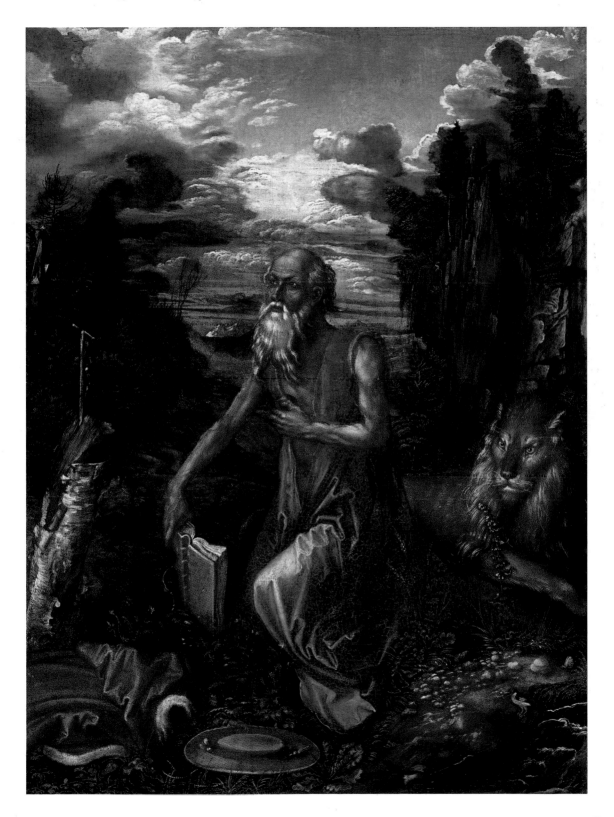

Once again, the route he took is still partly unknown. Even his arrival in Venice at the end of October 1494 has recently been questioned, since the paintings Dürer executed around that date betray none of the changes in his technique prompted by his exposure to Venetian art. But an overwhelming number of factors argue in favour of a visit to Venice, including a passage in a later letter by the artist himself and a comment made in 1508 by his friend Christoph Scheurl to the effect that Dürer had recently visited Italy for the second time. For this reason we may concur with Erwin Panofsky, who saw Dürer's first Italian journey – the archetype of all trips to the South by German artists – as the "beginning of the Renaissance in the countries of the North".

Several small paintings may have been executed in Venice, amongst them the minute panel of the *Penitent Saint Jerome* (ill. p. 15), surprising not least for the unusual celestial body which is painted on the back (ill. p. 14). Another may be the *Madonna and Child in front of an Arch* (ill. p. 17): rediscovered in the late 20th century, this panel came from a nunnery near Ravenna and has never left Italy. The infant Christ in particular corresponds to Italian models. Dürer was fascinated above all by the Madonnas of the universally admired Venetian painter Giovanni Bellini (c. 1430 – 1516; ill. p. 16), placed in front of a curtain or

Giovanni Bellini
Virgin Enthroned with Four Saints, 1488
Mixed media on panel, 184 x 79 cm (middle panel), 115 x 46 cm (each of the two side panels)
Venice, Frari church, Sacristy

Madonna and Child in front of an Arch, c. 1495
Mixed media on panel, 47.8 x 36 cm
Corte di Mamiano, near Parma, Fondazione Magnani Rocca

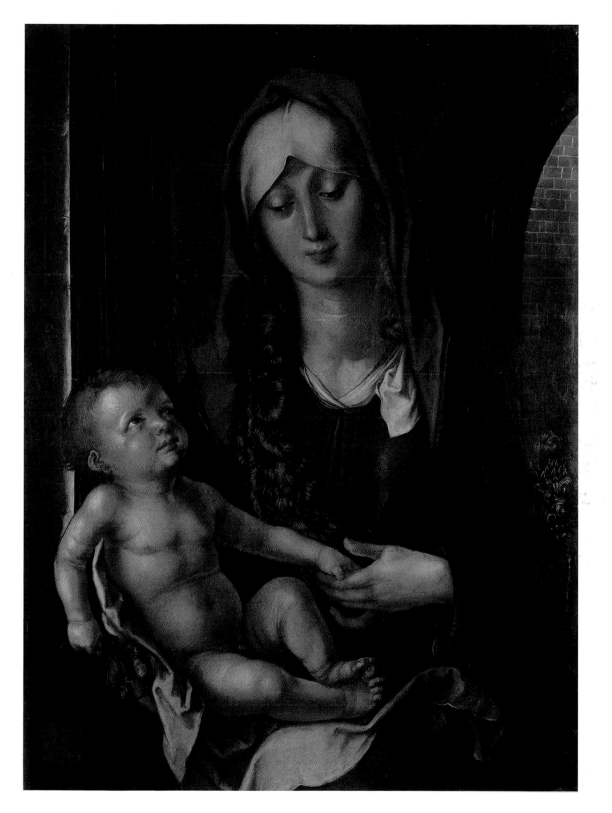

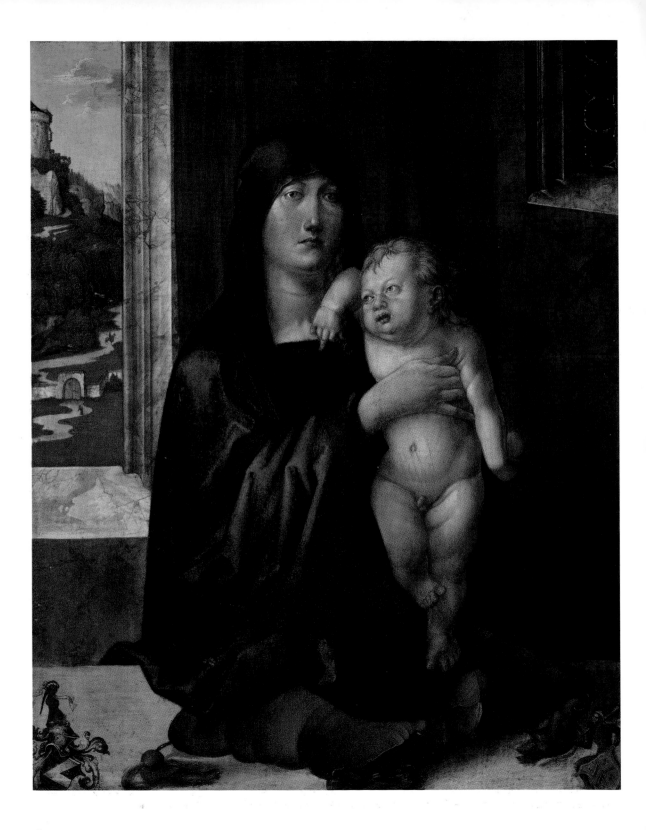

against a landscape view. Face to face with the symphony of colour and painterly flesh of Bellini's works, the Nuremberg artist, influenced by the dry manner of Wolgemut, must have experienced a revelation. Dürer quickly responded with the *Haller Madonna* (ill. p. 18) and a number of other works in the same manner.

Bellini's brother-in-law was Andrea Mantegna (1431–1506), whose sculptural nudes Dürer had already encountered in copperplate engravings available in Nuremberg. In Venice he would have seen more of his art, which rapidly led him, in copperplate engravings, to marry the study of nature with a language of form inspired by antiquity.

Above all, however, Dürer's watercolour technique (in which he employed a combination of watercolour and gouache) now assumed a boldness of such spontaneity that some modern art historians have felt compelled to draw comparisons with the *plein air* of Impressionism, with Cézanne and with Asiatic ink drawing. Indeed, one of these watercolours (ill. p. 20) depicts a fellow artist who is capturing his immediate impressions of the mountainous landscape in a sketchbook. Dürer was not the only one to employ such a motif; it is also found in the circle of Leonardo, for example in a pen drawing by Piero di Cosimo (1461/62–c. 1521) depicting a *Man Drawing in a Mountain Landscape* (New York, Lehman Collection).

A problem that remains unresolved is the chronology of Dürer's watercolour landscapes. Some, it is thought, were painted even before his first trip to Italy, including the well-known *Wire-drawing Mill* in the Berlin Kupferstichkabinett. The second group falls within the period September 1494 to February or March 1495: whether painted on the way to Italy or on the way back (and therefore whether inspired by Italian art or not) is a matter of individual debate. The situation is complicated by the fact that Dürer also produced watercolours on his second trip to Venice. *The Willow Mill* (ill. p. 23) was probably one of these, although some researchers date it earlier. This milestone in the history of the watercolour landscape renders the appearances of light, its refracted colours and the reflections on the water with an atmospheric consistency never seen before. The richness of the palette corresponds to the primacy that Dürer, under the influence of the Venetian masters, granted to colour from 1506 until 1511.

The watercolours that Dürer brought back from his first Italian journey, however, also rank amongst the most beautiful of their genre (ill. pp. 21 and 23). No one before had handled watercolour with such freedom and yet with such precision. The motifs almost "swim" on the paper, forgetting all the conventions of the late Middle Ages, which sought to fill every last inch of the pictorial surface. Dürer, so it seems, was deliberately savouring the fleeting nature of the visual impression, surrendering himself to a beauty hallmarked by momentary immanence.

For all the wonderment these watercolours arouse in the modern viewer, however, certain reservations should not be ignored. These compositions are undoubtedly the consequences of a new way of looking at nature. This was not, or at least not always, an end in itself, but rather a starting-point for preliminary drawings and studies. What seems so impressionistic – we need only examine the *Group of Trees with Path in the Mountains* (ill. p. 22) – in fact serves as underpainting, which Dürer proceeds to overlay with details in other sheets in a step-by-step process. Nevertheless: the mere concept of such underpainting is born of brilliant invention!

A watercolour of 1525 that "jots down" an apocalyptic landscape with just a few layers of wash serves quite a different purpose (ill. p. 25). The accompanying

Virgin with Suckling Child, 1503
Mixed media on limewood, 24 x 18 cm
Vienna, Kunsthistorisches Museum

It is likely, but not certain, that the painting was formerly housed in Prague in the collection of Emperor Rudolph II. Whether it reveals the influence of the Venetian painter Jacopo de' Barbari is also uncertain.

Madonna and Child (Haller Madonna), c. 1497
Mixed media on panel, 52.4 x 42.2 cm
Washington, National Gallery of Art
(Samuel H. Kress Collection)

The title *Haller Madonna*, by which the panel is also known, is derived from the coat of arms in the lower left-hand corner belonging to the patrician Haller family from Nuremberg. The coat of arms being supported by a Wild Man in the opposite corner is that of the Koberger family, related to the Hallers by marriage. In 1932 this exquisite panel was offered for sale at a London auction, still attributed to the hand of Giovanni Bellini.

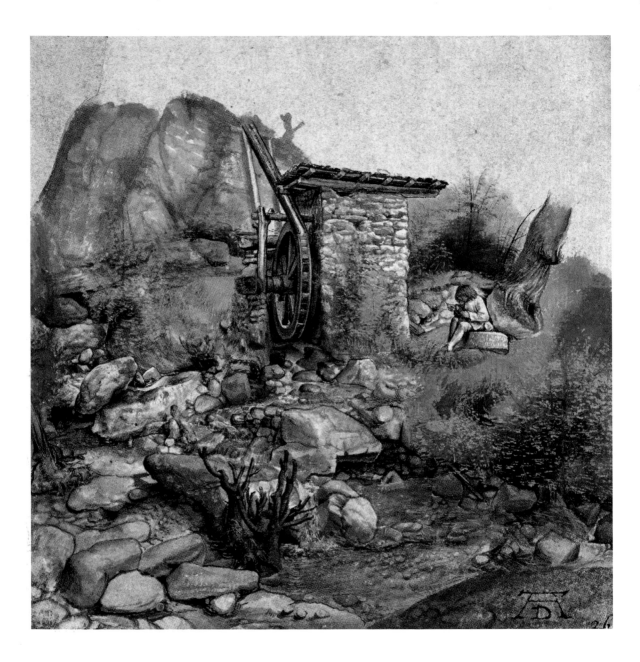

Watermill in the Mountains with Sketching Artist,
c. 1494
Watercolour and gouache, 13.4 x 13.1 cm
Berlin, Staatliche Museen zu Berlin – Preussischer Kulturbesitz,
Kupferstichkabinett

The Dürer monogram lower right has been added by a different hand.

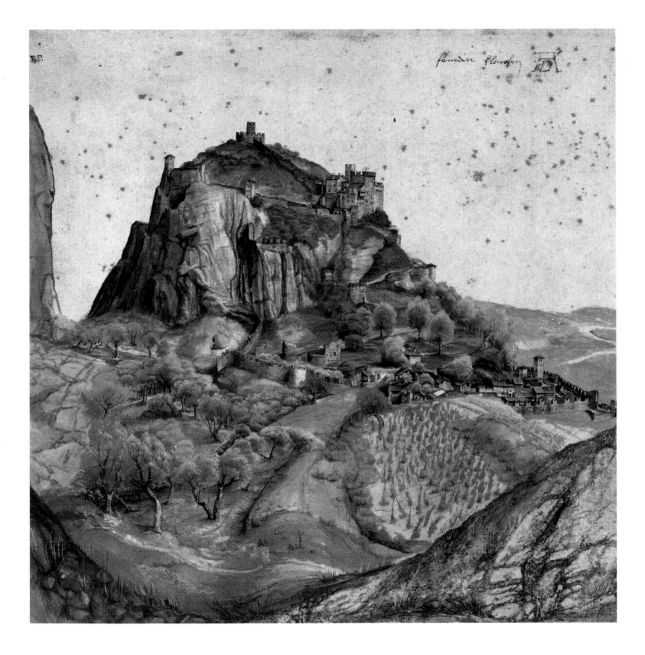

View of Arco, c. 1495
Watercolour and gouache, 22.1 x 22.1 cm
Paris, Musée du Louvre, Cabinet des Dessins

Dürer was on his way back from Venice when he executed this view of Arco,
a few miles from the northern shore of Lake Garda. With its carefully planned
composition and delicate colouring, it is probably the loveliest of his Italian watercolours.
Topographical accuracy was evidently not enough for the artist,
since he has brought together from memory several motifs that are not actually
visible from the spot where the view was painted. The watercolour's fame rests not
least on the curiosity concealed within it: an enormous, scowling face in profile,
which leaps out of the left-hand side of the rocky outcrop! A chance projection – or deliberate?

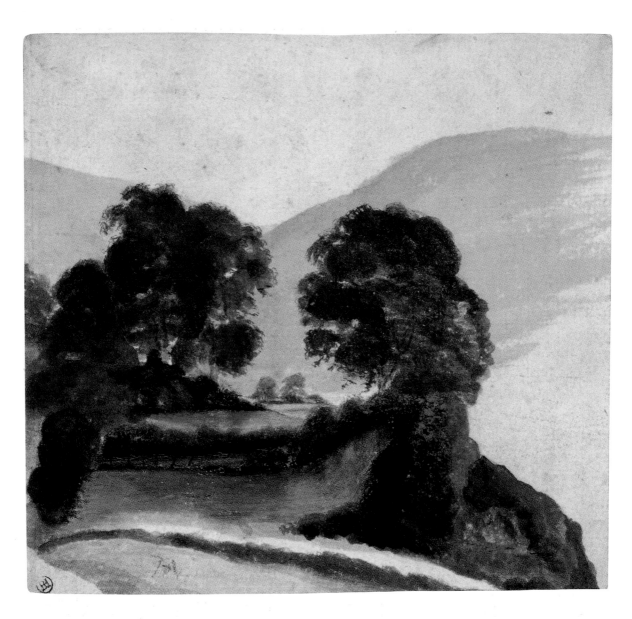

**Group of Trees with a Path
in the Mountains,** 1494
Watercolour and gouache, 14.2 x 14.8 cm
Berlin, Staatliche Museen zu Berlin –
Preussischer Kulturbesitz, Kupferstichkabinett

This motif was probably also painted in the
Val di Cembra and can therefore be dated to
autumn 1494.

PAGE 23, TOP:
The Willow Mill, after 1506 (?)
Pen and black ink (?), watercolour and
gouache, 25.3 x 36.7 cm
Paris, Bibliothèque nationale, Département
des Estampes et de la Photographie

The Paris watercolour is of outstanding
artistic quality. Its dating remains the subject
of contention even today, but not so the spot
from where the view was painted: the north
bank of the River Pegnitz, where it flows past
the Hallerwiese park outside Nuremberg's city
walls.

PAGE 23, BOTTOM:
View of a Castle by a River, 1494
Watercolour and gouache, 15.3 x 24.9 cm
Bremen, Kunsthalle, Kupferstichkabinett

This watercolour, whose Dürer monogram was
added by a different hand, was considered lost
after 1945. In 2000, however, it was returned
from Moscow to the Kunsthalle in Bremen
together with a bundle of 101 sheets. It now
seems confirmed that the castle depicted is
Segonzano in the Val di Cembra and therefore
that the watercolour was probably painted in
autumn 1494 on the way to Venice.

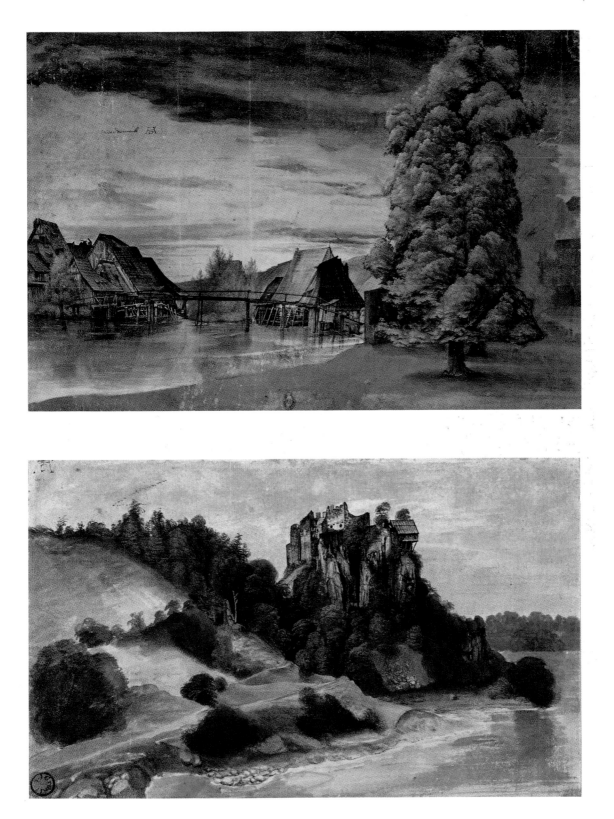

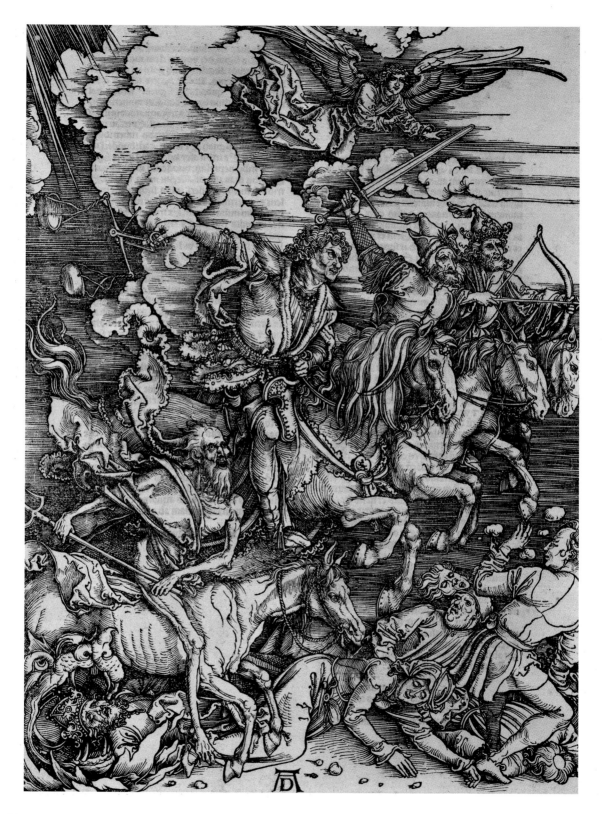

Vision, 1525
Watercolour, 30.5 x 42.5 cm
Vienna, Kunsthistorisches Museum

The Four Horsemen of the Apocalypse, 1498
Woodcut, c. 39.5 x 28.5 cm
Florence, Galleria degli Uffizi,
Gabinetto dei Disegni e delle Stampe

Some art historians interpret the phalanx
of riders charging down all before them as
personifications of Victory, War, Inflation
and Death. The horseman above Death may
also be interpreted as Hunger or alternatively
as divine justice, the archer as a symbol of
the plague.

text describes a nightmare in which the artist experienced torrential rain falling
like a flood. Dürer banishes his fear by subsuming it into factual information,
discussing how to indicate distance by means of a varying intensity of cloud
colour, and offering observations on the spattering of the water, the areas of
which he renders in a seemingly immaterial palette.

When Dürer returned to Germany from his first Italian journey, it was to an
overheated climate. Ulrich von Hutten (1488 – 1523), knight, humanist and poet,
greeted the new millennium of 1500 with the words: "O saeculum – o century!
It is a pleasure to be alive!" At the same time, there were rumours across the
land of the end of all things and of dark omens in the shape of comets and solar
eclipses, earthquakes and new floods, plagues and monstrous births. The An-
tichrist appeared to some in the armies of the Turks, moving ever closer to the
gates of Vienna from the Balkans, and to others in the guise of zealous do-gooders.

Dürer was interested in miraculous, sensational signs all his life. He also subli-
mated the – in many places widespread – eschatological mood of the era, above all
with his *Apocalypse,* a book of woodcuts published in 1498 and illustrating scenes
from the Revelation of St John (ill. p. 24). Intellectually one of the most challenging
pictorial cycles in Western art and probably the most important in his own œuvre,
it was the break that brought him international fame. With it, the medium of the
woodcut is lent a dramatic power previously unknown in European graphic art.

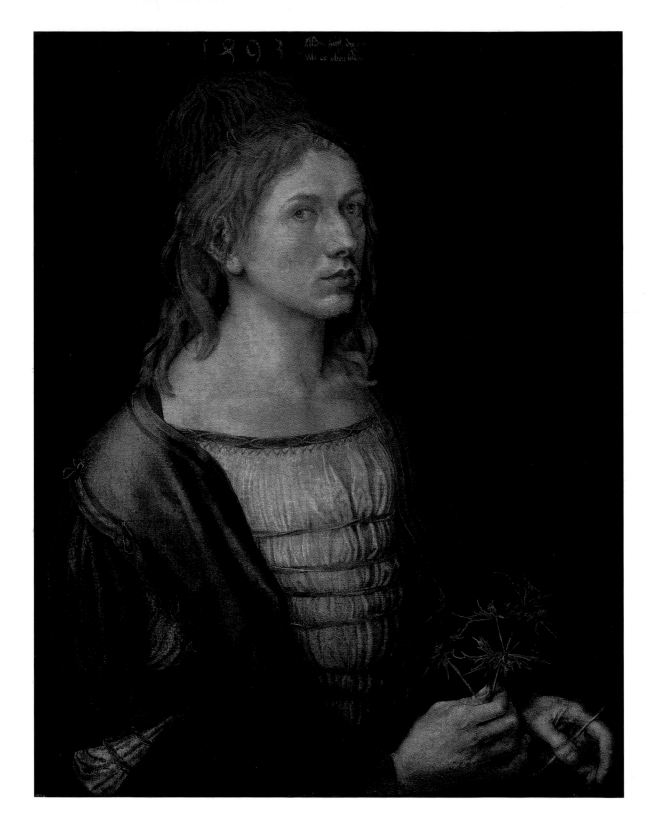

The mark of genius

The Nuremberg to which Dürer returned home from Italy was largely untroubled by apocalyptic angst, however. Around 1500, in its golden era, the city was rich in goods and people. Although demographic data vary, a figure of around 45,000 inhabitants seems plausible. Within the Holy Roman Empire, only Cologne, with a population of around 60,000, was bigger. Nuremberg maintained a broad network of trade links right across Europe. The Pirckheimer family supplied the Venetian mint with silver right up to 1492.

The outward-looking metropolis was governed by a patrician oligarchy with the assistance of the Lower Council. This was subordinate to the Upper Council. Goldsmiths, painters and book printers could occasionally rise to the ranks of the Lower Council – as Dürer did himself in 1509 – but for the rest of the time artists and craftsmen producing luxury items were denied any role in politics. By way of compensation, they were spared the constraints imposed by membership of a guild – something to their benefit. For the arts, like the sciences, were booming in Nuremberg.

Amongst his fellow painters, woodcarvers and metalworkers, Dürer occupied a distinct, "avantgardist" position. This was something that Nuremberg's chief notables – humanists such as Sebald Schreyer (1446 – 1520), Hartmann Schedel (1440 – 1514) and Konrad Celtis (1459 – 1508), and above all the patrician Willibald Pirckheimer (1470 – 1530; ill. p. 27), who was the same age as Dürer and his close friend – never tired of emphasising. It was probably Pirckheimer who secured Dürer the early commission for a portrait of the Saxon Elector Frederick the Wise (1463 – 1525; ill. p. 30).

Dürer initially established his reputation at home and abroad not with paintings, however, but with copperplate engravings and editions of woodcuts. Not without reason does his "AD" monogram make its first appearance in his graphic works of around 1495, in the engraving of the *Holy Family with a Dragonfly.* From now on his trademark served across Europe as a seal of artistic quality, not least at the Frankfurt trade fair. Shortly after 1500 Dürer set up his own workshop in Nuremberg, in which he employed his brother Hans (1490 – 1534/35) and also – as his most important assistant – Hans Baldung Grien (1484/85 – 1545).

Dürer's two earliest self-portraits in mixed media also seem to fit the image of a man bent on success. In the first, probably executed in Strasburg in 1493 while Dürer was still a journeyman, the 22-year-old holds in his delicate hands

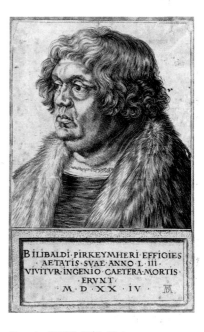

Portrait of Willibald Pirckheimer, 1524
Copperplate engraving, 18.1 x 11.5 cm

Beneath the bust, which is presented in three-quarter view, a stone tablet bears the antique-style inscription identifying the sitter. Dürer has here improved upon his friend's less than handsome looks to present him as an idealised image of a humanist.

Self-portrait, 1493
Mixed media on vellum (transferred to canvas c. 1840), 56 x 44 cm
Paris, Musée du Louvre

Cut agate – reverse of the Karlsruhe panel

On the reverse of *Christ as the Man of Sorrows*, Dürer has painted a cut agate in the manner of a *trompe l'œil* – as if wishing to demonstrate even at this early stage that his remarkable talent extends not just to drawing but also to the handling of colour. Whatever the case, the illusion that he achieves can be compared with his skilful imitation of the stone parapet on the front of the panel. Whether Dürer was thinking of the symbolism of agate – an allusion to contempt for and the overcoming of this worldly life – and was intending to use it as the material of Christ's tomb in his *Man of Sorrows*, must remain open.

Christ as the Man of Sorrows, c. 1493/94
Mixed media on fir, 30.1 x 18.8 cm
Karlsruhe, Staatliche Kunsthalle

The gold ground has been pounced with the outlines of thistles, which link to the Passion and deliverance of Christ, and also with the figure of an owl being attacked by birds. The attack by daytime birds on the nocturnal bird of prey usually symbolises the battle between Good and Evil; here, however, it is more likely to refer to the innocent who is persecuted and Christ's loneliness in the tomb in line with Psalm 102:7.

a thistle-like flower from a plant known as "husband's fidelity", of the genus *Eryngium* (ill. p. 26). The flower has been interpreted as a symbolic reference to Dürer's impending marriage. This idea would appear to find support in the fact that the portrait is painted on vellum and would therefore have been easy to roll up – in order to send it back to Nuremberg, perhaps? As an engagement present for Agnes and her parents?

That *Eryngium* sooner carries religious associations is implied by the inscription at the top of the painting, however: *My sach die gat / Als es oben schtat* – "Things with me fare as ordained from above". The plant is also found in the gold ground of the Karlsruhe *Man of Sorrows* from this same period (ill. pp. 28 and 29). It is possible that Dürer made the acquaintance in Strasburg of the Gottesfreunde (Friends of God), a lay fellowship whose mystical orientation centred round the life and Passion of Christ.

The Prado half-length *Self-portrait* of five years later (ill. p. 2), Dürer's first major success in panel painting, is intentionally more splendid than the Louvre picture. The material texture of the gloves is rendered in grandiose fashion, as is the panorama of mountains glimpsed through the light-filled window. Dürer is dressed in his finest attire: over a white shirt trimmed with gold braid he wears a white doublet cut very low at the front. The black and white stripes of the long sleeves are taken up again in the artist's unusual hat. His brown coat is secured by a blue and white cord, and he sports the "gentleman's attribute" of leather gloves. One might conclude that Dürer, who officially only enjoyed the rank of craftsman in the Nuremberg corporative system, is emphasising the exclusive prestige of a Renaissance artist in the same year in which he was admitted to the Herrentrinkstube (Gentleman's Taproom), a club for patricians.

Dürer drew and painted a whole series of self-portraits, as well as including his own figure within a number of altarpiece compositions. Ranking amongst the ultimate explorations of the self is the Weimar pen drawing on a green ground (ill. p. 95). It is the first nude self-portrait by an artist to have come down to us – even if it was never intended for public viewing. The body is shown down to the knees. Dürer is wearing a hairnet. On his lanky body with its long thighs, the skin has begun to droop in a number of places. The merciless naturalism – and at the same time seeming narcissism – of this attack on his own appearance also extends to his genitals and the shadow they cast. The anthropology that he visually probes extends just as much to the flesh of his sex as to the questioning look in his wide eyes. There is already a strong libidinous flavour to the drawing *Youth with Executioner* of around 1493 (ill. p. 32). The victim, a young man, is kneeling almost entirely naked before the executioner. Rather than raising his sword to deal the fatal blow, however, the latter is stroking the semi-naked youth, who is evidently enjoying the caress. The executioner's organ in its pouch thrusts itself voluminously between the delinquent's arm and upper body. Punishment and pleasure seem to belong together. In the medieval system of justice, a person sentenced to death was delivered into the hands of the executioner before the execution and was physically theirs, even for the raping – young men included. Humanist friends once or twice alluded loosely to the fact that Dürer had pederast leanings. It is nevertheless questionable whether one can conclude from this or from the present drawing that the artist was a practising homosexual – something punishable by death in the Nuremberg justice system of the day. Dürer seems to have been fascinated by the subject, however.

In Dürer's most famous *Self-portrait* (ill. p. 31), from the year 1500, his face emerges from a dark, shapeless background with an enigmatic intensity that

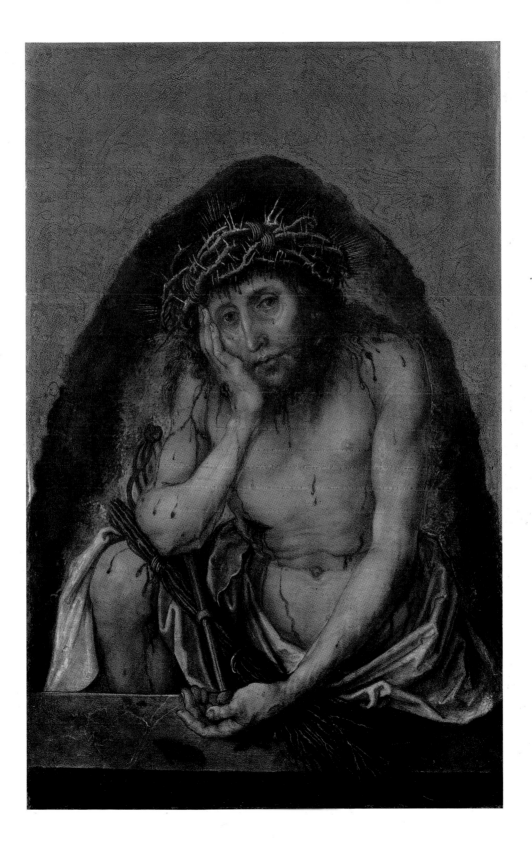

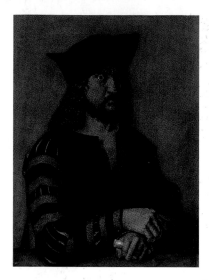

**Portrait of Elector Frederick
the Wise of Saxony,** 1496
Tempera on canvas, 76 x 57 cm
Berlin, Staatliche Museen zu Berlin –
Preussischer Kulturbesitz, Gemäldegalerie

The portrait was probably painted when the
Elector and his brother visited Nuremberg.
The authenticity of the signature is disputed.

Self-portrait in a Fur Coat, 1500
Mixed media on limewood, 67 x 49 cm
Munich, Bayerische Staatsgemälde-
sammlungen, Alte Pinakothek

In Nuremberg in Dürer's day, the new year
started on 25 December. Since the inscription
in this famous self-portrait gives the artist's
age as twenty-eight, the painting must have
been executed between the last week of 1499
(by modern reckoning) and 21 April 1500,
Dürer's twenty-ninth birthday. It seems that
the panel never left Dürer's studio during
his lifetime. Soon after the death of the artist,
it passed to Nuremberg town hall.

recalls Leonardo's *Mona Lisa.* Striking is the high forehead, which Dürer did not possess; striking the "noble" nose and the wide open eyes, their unfathomable gaze directed out at the viewer. The artist has embellished, too, his magnificent curly locks (for which his friends so often teased him), twisted into strands like metallic threads and falling in strict verticals down either side of the face – and in a cowlick over the forehead.

The purely frontal view and the idealized facial symmetry establish a detachment that immediately recalls the majestic format of much earlier Christ icons. The head and bust appear contained within a network of construction lines. Modern research has attempted – in vain – to reconstruct the binding coordinates, the intellectual synthesis of the whole. Some interpreters have seen the resemblance of Dürer's face to Christ, the fusion of the artist's imperfect nature with the perfection of divine beauty, as hubris. Hence the attempts to legitimise its presumptuousness – not least with the aid of the window bars reflected in his right eye, which elevate the organ metaphorically to the "window" or "mirror" of the soul. This, it is suggested, invokes the Neoplatonic concept of a *humanitas* that rises above the physical to the spiritually transcendent. It might also fall in line with the teaching – addressed to lay Christians – of the *imitatio Christi,* the mystical imitation of the Saviour; this teaching finds literal expression in a German figure of speech, according to which "the believer should have Christ's cross in view his whole life long".

Without dismissing religious (and Neoplatonic) meanings of this kind, it is also possible to consider an interpretation currently favoured by modern research. This arises out of the four-line inscription on the right-hand side of the panel: *Albertus Durerus Noricus ipsum me propriis sic effingebam coloribus aetatis anno XXVIII* (Thus I, Albrecht Dürer of Nuremberg, have painted my likeness at the age of 28 years in my proper colours). It also relies on Christoph Scheurl, who in 1508 compared Dürer with Apelles, the most famous artist of antiquity, and then proceeded to talk about the *Self-portrait* of 1500. According to Scheurl, Dürer painted it in front of a mirror following the example of Marcia, the daughter of Marcus Varro. The story of this female artist was told by Pliny the Elder in the 1st century AD and passed on to the Renaissance by Boccaccio in his book of famous women (*De claris mulieribus,* 1360/62).

The key element of the story of Marcia was evidently the painting of a likeness from a mirror. What should be remembered is that the only mirrors available even in 1500 were small and convex. Not until 1516 did glass-workers in Murano succeed in manufacturing the very first flat mirrors. Transferring a face from a mirror whose surface curved outwards to the flat pictorial plane therefore posed an enormous technical challenge. The very first solution to this problem had been attributed to a mythical woman artist of classical antiquity. Now it was Dürer who demonstrated the ability to transfer a convex curving reflection (analogous to the window on his eyeball) onto a flat panel and thereby remain faithful to nature. It was also thought that the colours in a reflection were modified. Hence one might understand the reference in the inscription to *proprii colores* as alluding to the difficulty of achieving the correct colours in a painting.

In 1512 Dürer observed: "… for a good painter is full of invention within […] and were he able to live for ever, he would always have something new to bring forth." His words probably go back to Neoplatonic thinking, whereby the creative ability encapsulated in the phrase "full of invention within" provides a key to the Munich self-portrait. The sitter's eye represents the power of sight, the eye with whose assistance an original image is reproduced. The hand that Dürer presents

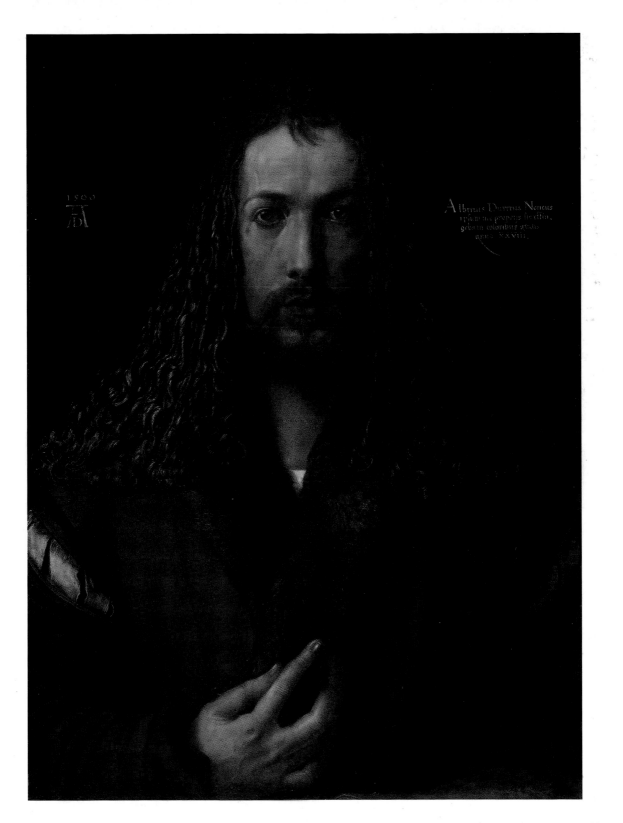

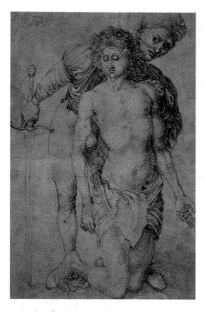

Youth with Executioner, c. 1493
Pen and ink, 25.4 x 16.5 cm
London, The British Museum,
Department of Prints and Drawings

in such a mannered and demonstrative way at the bottom of the picture stands for the manual skill, the practical craftsmanship that allows the "image" to be realised as a painting. It follows that the Munich *Self-portrait* may represent a discussion on the medium of the picture and its ability to convey beauty – which would not exclude the religious (and Neoplatonic) interpretations outlined above. On the contrary, it would raise the concept of beauty to metaphysical heights!

His thoughts probably set in motion by his first trip to Italy, Dürer pondered the nature of ideal beauty in ever greater depth from 1500 onwards. In the spirit of the Renaissance, he believed that the beauty of the gods of classical antiquity should set the supreme standard in art, even where the subjects portrayed were Christian. He was able to refer to the verse in the apocryphal Wisdom of Solomon (11:20), according to which God had "arranged all things by measure and number and weight". Dürer became a leading champion of an aesthetic determined by divine harmony and proportion, although he never lost sight of its practical application in art: "I wish here to light a small fire. If you all add your own contribution with skilled perfection, then [...] a fire may be built up that will light up the whole world."

The Venetian artist Jacopo de' Barbari (1460/70 – 1516), who travelled and worked across half of Europe, was a leading light in this respect, so Dürer believed. He was rumoured to have discovered the secret of a system of ideal measurements and proportions. Like an alchemist pursuing the philosopher's stone, Dürer chased after Barbari's mathematical and theoretical findings – without ever setting eyes on them, without ever discovering if they even existed. Perhaps he had met Barbari briefly during his first journey to Italy. And perhaps the search for such ideals was the main reason for his second visit to Venice. There may have been another reason, too: the deadly plague seems to have broken out again in Nuremberg at the end of July 1505. The chronicles report that the number of victims exceeded even the catastrophe of 1494. Those who could afford to do so left the city. Dürer sent his wife Agnes, with woodcuts and engravings in her luggage, to the autumn trade fair in Frankfurt and set off himself on the ride across the Alps.

Beyond the mountains, luring him back, was the city of lagoons, of light and of a painting intoxicated with colour: Venice. A metropolis even in those days, it is estimated to have been home in the middle of the 16th century to a population of some 175,000 (a figure that would not have been significantly lower around 1500) – including the allegedly 11,000 prostitutes and courtesans described by chronicler Marino Sanudo.

Art historians have devoted immense effort to reconstructing the trips that Dürer made from Venice. That he went to Bologna is firmly established. But did he also go to Florence, or even to Rome? Did he meet Leonardo or Raphael, with whom he later exchanged pictures by post, in person? To discuss the arguments for and (more likely) against such scenarios would lie outside the framework of this book. We shall restrict ourselves to Dürer's activities in Venice, information about which can be found in the ten letters that he wrote to Pirckheimer between 6 January and 13 October 1506. At times they are of shocking intimacy. He writes of the handsome young soldiers on the Rialto, who would please the sex-hungry patrician. In another passage, Dürer speaks of Agnes: if by threatening to sleep with his wife, Pirckheimer was hoping to make him come home, he would only succeed if she gave up the ghost while they were at it. Moreover he should write and tell him how he had used the "old crow" so that he, Dürer, would also have some of the benefit.

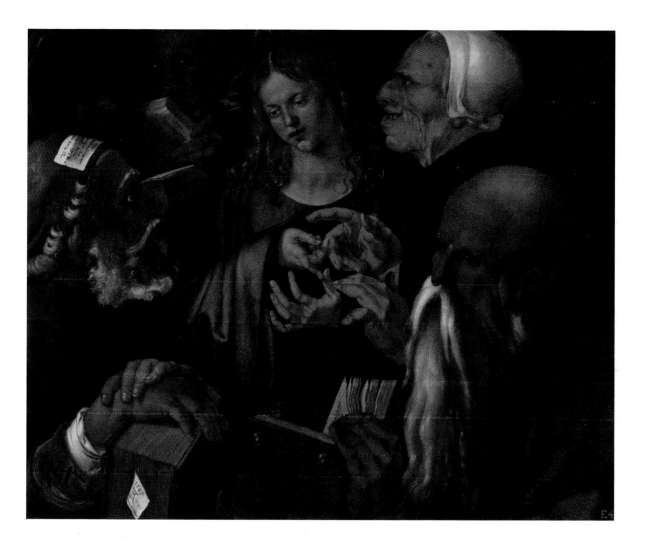

He describes his relationship with his Venetian colleagues, with the exception of the ageing Giovanni Bellini, initially in very negative terms. He was warned, for example, against their poisonous attacks. Dürer took out a lawsuit against Marcantonio Raimondi (c. 1480 – c. 1530), who copied his prints and forged his AD monogram: the first copyright action in history! Soon, however, Dürer found himself being venerated as a great artist. In 1506 he wrote fervently to Pirckheimer: "How I shall freeze after this sun. Here I am a gentleman, at home a parasite."

The portrait of a *Young Venetian Woman*, probably a courtesan, is attractive beyond compare (ill. p. 35; the suggestion that it is not quite finished, as is still occasionally claimed, is refuted by a restoration of 1965 / 66). The close-up view of the head, omitting the shoulders and arms, takes up the format of Venetian portraiture and the hairstyle in the Venetian fashion between 1500 and 1510. A second portrait of a young woman (ill. p. 84) is undoubtedly equally influenced by Venetian painting in the sensual quality of its surface treatment.

The *Madonna with the Siskin* (ill. p. 39) demonstrates clear affinities with comparable compositions by Giovanni Bellini, who had so greatly impressed

Christ Among the Doctors
(**Opus quinque dierum**), 1506
Mixed media on poplar, 64.3 x 80.3 cm
Madrid, Museo Thyssen-Bornemisza

In 1959 a copy of this painting came to light: executed in the form of a drawing (now lost), it bore the additional inscription "F[ecit] ROMA[e]". Remains of such an inscription were also revealed when the painting was cleaned in 1958/59. No trace of this can be seen today, however. A second drawn copy (Madrid, Thyssen-Bornemisza Collection) appeared to provide the final proof that Dürer made a trip to Rome. This suggestion is dismissed almost unanimously by modern art historians, however.

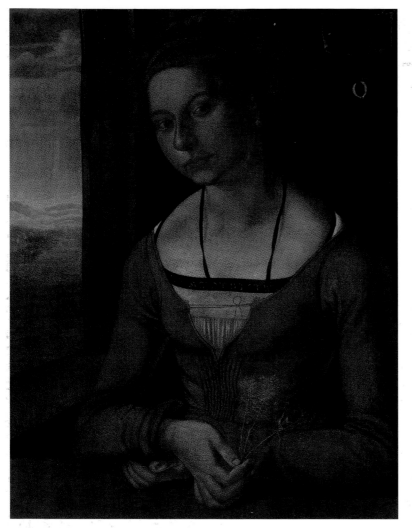

*Portrait of a Young Fürleger
with Braided Hair,* 1497
Tempera on canvas, 58.5 x 42.5 cm
Berlin, Staatliche Museen zu Berlin –
Preussischer Kulturbesitz, Gemäldegalerie

The portrait of a young female member of
the Fürleger family, part of the Nuremberg
patriciate, exists in two versions. The present
painting, which has belonged to the Gemälde-
galerie in Berlin since 1977, is considered to
be the original.

Dürer on his first trip to Venice. The siskin refers to the legend whereby the
Infant Jesus brought to life a toy bird made of clay – a symbol of his own future
Resurrection. Dürer was rightly proud of this enchantingly lovely devotional
painting.

 The last work that Dürer completed in Venice was the *Portrait of a Young
Man* (ill. p. 37). Painted on its reverse is an aged hag with a moneybag (ill. p. 36),
who has been interpreted as an allegory of Avarice, or perhaps more accurately
as a symbol of transience. There is much to support the argument that Dürer's
"Old Woman" was conceived at more or less the same time as the painting
La Vecchia attributed to Giorgione (1477 / 78 – 1510; ill. p. 37), in a climate of
mutual inspiration or rivalry – and that both works go back to a lost prototype
by Leonardo da Vinci.

 On his painting of *Christ Among the Doctors* (ill. p. 33), Dürer proudly noted:
"opus quinque dierum" – the work of five days. This act of bravura was carefully
planned in a series of preparatory drawings. Dürer thereby drew upon a number

Young Venetian Woman, 1505
Mixed media on spruce, 32.5 x 24.5 cm
Vienna, Kunsthistorisches Museum

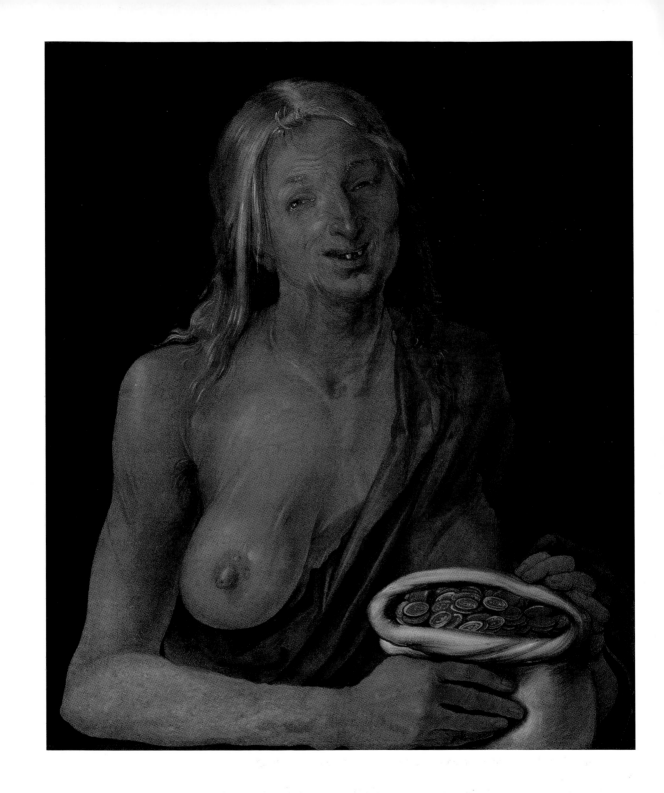

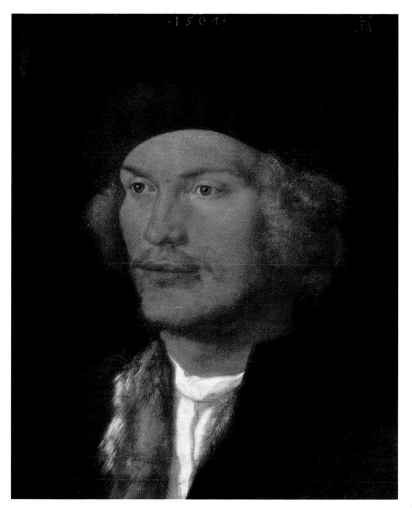

Portrait of a Young Man, 1507
Mixed media on panel, 35 x 29 cm
Vienna, Kunsthistorisches Museum

This double-sided panel bears the bust of
a young man on one side and, on the reverse,
a repulsive hag. Dating from the beginning
of 1507, it was the last work Dürer executed
in Venice.

Giorgione
La Vecchia, c. 1507
Tempera and walnut mixed media on canvas,
68 x 59 cm
Venice, Galleria dell'Accademia

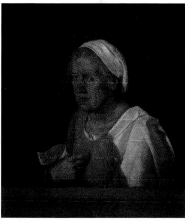

of sources: the crowded compositional format used by Mantegna and Bellini's
circle and Leonardo's "grotesque heads".

The greatest achievement of his second stay in Venice, however, was the
Feast of the Rose Garlands (ill. p. 62). This monumental altarpiece was com-
missioned by the German merchants in Venice for "their" church of San Barto-
lomeo, and was probably paid for by a Confraternity of the Blessed Rosary. The
Doge and the Patriarch both admired the finished work, so Dürer wrote proudly
back home, and the Doge made him a fabulous offer in order to keep him in the
city. One hundred years later the painting caught the eye of Emperor Rudolph II,
who bought it in 1606. He had it carried from Venice to Prague as if in proces-
sion. In the Thirty Years' War the painting was removed to Budweis for safekeep-
ing. On its return journey to Prague in 1635 it suffered such extensive damage
that the Swedes, when they came to plunder Hradčany castle in 1648, passed over
the painting altogether. Despite numerous attempts at restoration, the painting
remained a ruin.

Nevertheless, enough can still be seen of its magnificent palette and its com-
positional and theatrical intelligence for the modern viewer to understand the

Vanitas, 1507
Reverse of the *Portrait of a Young Man* panel.

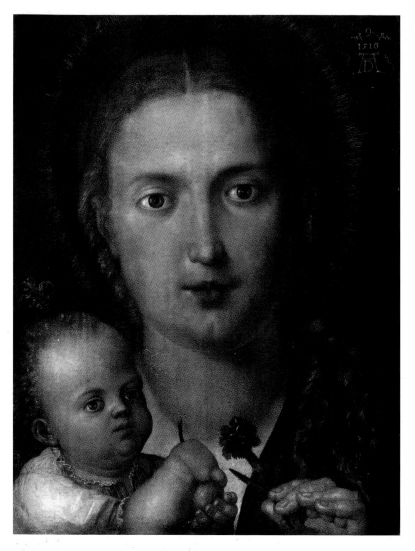

Madonna with the Carnation, 1516
Painting on parchment over softwood,
39 x 29 cm
Munich, Bayerische Staatsgemälde-
sammlungen, Alte Pinakothek

The carnation that the Virgin holds before
the Child is a symbol of the Passion. Its leaves
and fruit echo the shape of a nail and are thus
associated with the Crucifixion.

glowing reception it enjoyed in its own day. Within the landscape format, Dürer
stages a "summit meeting" of supreme dignity in front of the enthroned Ma-
donna. The beautiful young Virgin is dressed in a luminous blue dress of a Ve-
netian cut and wears her hair in the Venetian fashion. She places a garland of
roses on the head of the kneeling Emperor Maximilian I, while the Infant Christ
reaches towards the Pope to do the same. The angel playing the lute at the Vir-
gin's feet, in the manner of figures by Bellini, wears robes of dazzling gold. His
wings shimmer in multiple colours and recall Dürer's exquisite study of a roller's
wing (ill. p. 40). Elsewhere, cherubs crown other worshippers with further rose
garlands. Dürer includes himself on the right, against the mountain backdrop.

An imperial crown rests on the ground in front of the secular ruler, even
though Maximilian did not yet hold the corresponding title. It has been con-
vincingly suggested that Dürer wished to propagate the ideal of harmony be-
tween the most senior secular sovereign and the head of the Church. The gesture
that Maximilian makes towards the Pope kneeling opposite him is a visualization

Madonna with the Siskin, 1506
Mixed media on panel, 91 x 76 cm
Berlin, Staatliche Museen zu Berlin –
Preussischer Kulturbesitz, Gemäldegalerie

Titian saw this panel in Venice before Dürer
took it back to Nuremberg and made it the
basis of his own *Madonna of the Cherries*
(Vienna, Kunsthistorisches Museum).

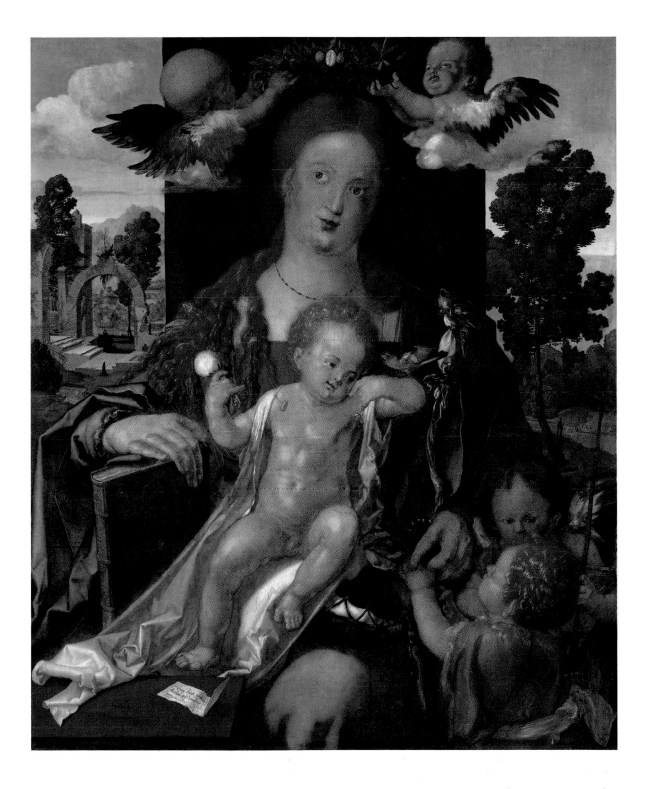

Wing of a Roller, c. 1500 (or 1512)
Watercolour and gouache on parchment,
heightened with opaque white, 19.6 x 20 cm
Vienna, Graphische Sammlung Albertina

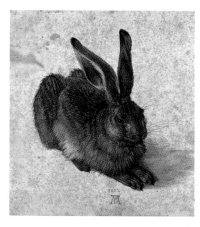

PAGE 41:
Large Piece of Turf, 1503
Watercolour and gouache, heightened with
opaque white, mounted on cardboard,
40.8 x 31.5 cm
Vienna, Graphische Sammlung Albertina

Hare, 1502
Watercolour and gouache,
heightened with opaque white, 25 x 22.5 cm
Vienna, Graphische Sammlung Albertina

of his request to be crowned Holy Roman Emperor, something that the Virgin
anticipates with the rose garland.

In a letter to Pirckheimer of 8 September 1506, Dürer writes that after seeing
The Feast of the Rose Garlands, the Venetian painters, who had previously denied
him any skill with colour, were full of admiration: never had they seen more
beautiful colouring. Erasmus of Rotterdam later considered Dürer's triumph to
lie not in his handling of colour but in his use of black and white: in the compe-
tition between the arts, the possibilities of colour painting were "overshadowed"
by his graphic works. Similar attitudes were frequently voiced in the early 16th
century in a spirit of anti-Italian propaganda. In the domain of graphic art, the
message ran, Germany and the Netherlands remained unbeatable, even in an
age when the Italian Renaissance appeared to be dominating all. For Dürer him-
self, another key concept was undoubtedly even more important: "For verily art
[by which he means all the rules of proportion and geometry governing art] is
embedded in nature, and whoever can draw her out, has her."

And he "drew" her out! Replying to the emphasis upon colour inspired by
the South was – as always – the detailed draughtsmanship, the "microscopy" of the
nature studies that Dürer produced before his second trip. These include the
watercolour of a wild *Hare* (ill. p. 40), its fur is breath-takingly vivid and its eyes
taut with fear. Also, the *Large Piece of Turf* (ill. p. 41), an arrangement of grasses
and puddles seen from the angle of an insect. In this only seemingly random snap-
shot of nature, the tallest grass divides the picture widthways into the harmony of
the Golden Section. Ordered and proportioned, the apparent chaos loses its casual
confusion. In its hidden "symmetry" it is an example of divinely created growth.

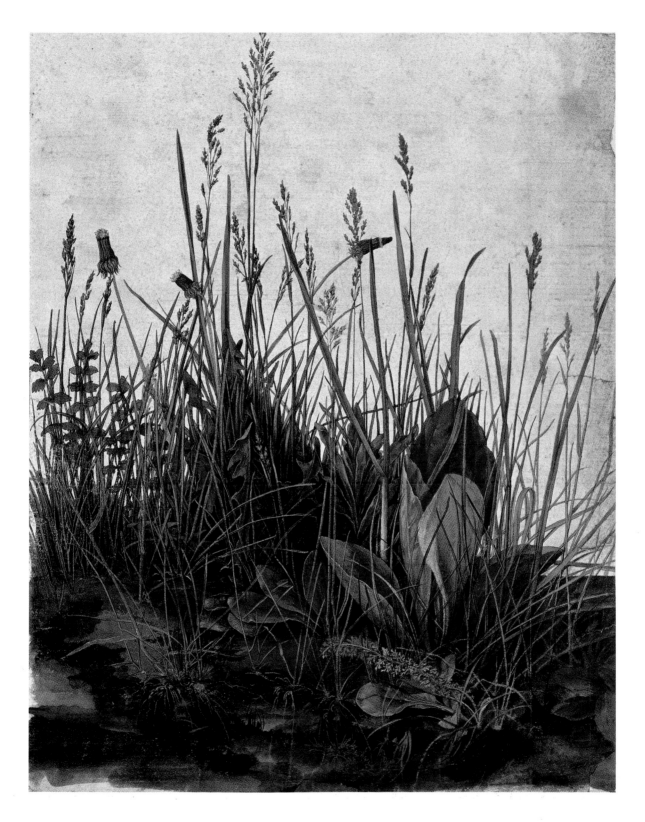

POTENTISSIMVS·MAXIMVS·ET·INVICTISSIMVS·CÆSAR·MAXIMILIANVS
QVI·CVNCTOS·SVI·TEMPORIS·REGES·ET·PRINCIPES·IVSTICIA·PRVDENCIA
MAGNANIMITATE·LIBERALITATE·PRÆCIPVE·VERO·BELLICA·LAVDE·ET
ANIMI·FORTIDVDINE·SVPERAVIT·NATVS·EST·ANNO·SALVTIS·HVMANÆ
M·CCCC·LIX·DIE·MARCII·IX·VIXIT·ANNOS·LIX·MENSES·IX·DIES·XXV
DECESSIT·VERO·ANNO·M·D·XIX·MENSIS·IANVARII·DIE·XII·QVEM·DEVS
OPT·MAX·IN·NVMERVM·VIVENCIVM·REFERRE·VELIT·

42

For City and Emperor

Nuremberg was a Free Imperial City, in other words subject only to the Emperor, and since 1423 had played host to the imperial relics and regalia. Alongside Aachen, site of the coronation, and Frankfurt, site of the election, Nuremberg thus ranked as one of the major imperial cities and until 1520 was indeed considered the most important within the Holy Roman Empire of the German Nation.

In 1510 the city council commissioned Dürer to produce a pair of panel paintings of Charlemagne (ill. p. 45) and Emperor Sigismund. The half-length figures, depicted larger than life, were destined to hang in the Treasure Chamber in the Schopper House on Nuremberg's market square, where the imperial regalia and coronation robes were brought on the eve of their annual ceremonial display.

Dürer applied himself conscientiously to the planning of the commission and made ink and watercolour studies of the robes, crown, sword, orb and glove, which he then translated into oil. The rather stiff formality of the finished portraits is not entirely satisfactory; the ceremoniousness is only relieved by the more animated expressions of the faces.

When Maximilian I (1459 – 1519) engaged the services of Nuremberg's most important artist in 1512, he must have hoped to earn himself a reputation as a discerning patron of the arts. It may have been Maximilian's banker, Jakob Fugger the Rich, who brought Dürer into the imperial circle: Albrecht had designed epitaphs for the Fugger funerary chapel in Augsburg two years earlier. It is also conceivable that Pirckheimer or Elector Frederick the Wise arranged the introduction. Whatever the case, Dürer now used the name of court painter. He sketched his new patron at the Imperial Diet in Augsburg in a chalk drawing of 1518 (Vienna, Albertina). This was followed by a woodcut and – also in 1519, after the Emperor had already died – the impressive painting in Vienna (ill. p. 42).

Maximilian, "the last knight", came much closer to the Renaissance ideal of the highly-cultured, widely-educated "universal man" than to the image of a medieval sovereign. He was unusual in recording his life and deeds in autobiographical writings; woodcuts illustrating *Freydal*, his book on tournaments, were produced in Dürer's workshop in 1516. Dürer's assistants Hans Springinklee and Hans Schäufelein were also peripherally involved in the illustrations to *Der Weisskunig* (The White King), which again extols Maximilian's prowess in chivalric combat, but did not work on any of his other books.

Page 41 from Emperor Maximilian's Prayerbook illustrated with the figure of an American Indian, 1514
Pen and red, green and purple ink on parchment, 28 x 19.5 cm
Munich, Bayerische Staatsbibliothek

Emperor Maximilian I, 1519
Mixed media on limewood, 74 x 61.5 cm
Vienna, Kunsthistorisches Museum

The painting bears Dürer's monogram and, in the top left-hand corner, the imperial coat of arms with the double-headed eagle surrounded by the ceremonial chain of the Order of the Golden Fleece. To the right, a lengthy inscription in Latin praises the achievements of the head of the Habsburg family.

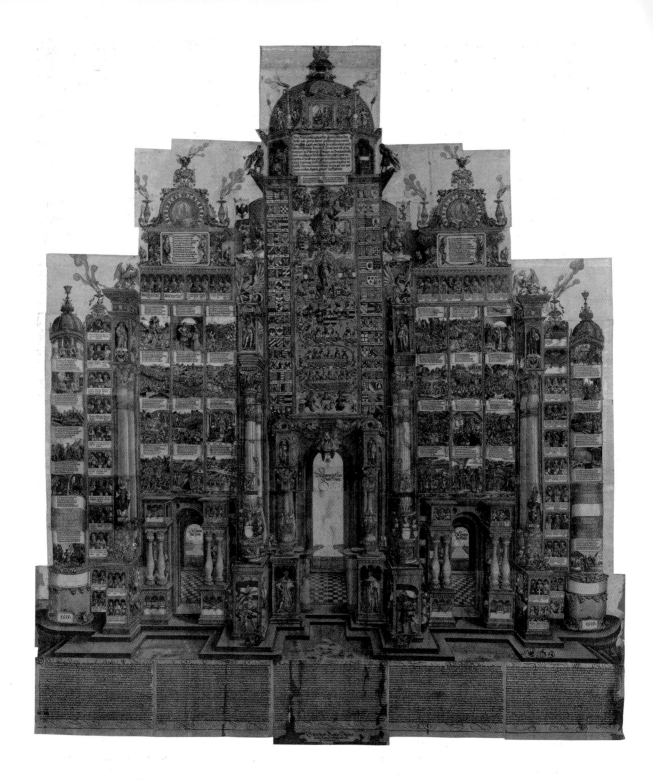

44

The mass medium of the woodcut was also the vehicle chosen by the Emperor to preserve his memory for posterity in two commissions on a monumental scale: the *Triumphal Arch* and *Triumphal Procession*. These "monstrous" woodcut assemblages were to be displayed in libraries, archives and art galleries across the Empire.

Measuring 357 x 295 cm (giving it a surface area of nearly ten square metres!) and made up out of 192 separate printing blocks, Maximilian's *Triumphal Arch* (ill. p. 44) is the largest woodcut of all time. The bulk of the work was executed by a team of artists and the form-cutter Hieronymus Andreae under Dürer's overall supervision. The two outermost columns were conceived by the great Regensburg master Albrecht Altdorfer (c. 1480 – 1538). Dürer himself – probably from 1512 onwards – designed the central tower bearing the imperial family tree and, enthroned at the top, a composite being, a cipher for the person of Maximilian. This paper arch of triumph was inspired not only by the influential prints issuing from Upper Italy but also by literary models and small-scale works of antique art.

Work on cutting the wooden blocks began in 1515 and in 1517 a specimen impression was dispatched to the imperial court. Not until 1518 was the first complete approved edition printed. After Maximilian's death, Dürer published a second edition whose proceeds he was allowed to keep.

In Maximilian's *Triumphal Procession*, only the *Great Triumphal Car* (ill. p. 46), completed in 1518, stems from Dürer. The procession as a whole comprises 137 woodcuts in a sequence totalling 55 metres in length! The pictorial frieze – an analogy to the *trionfi* (triumphs) staged in the Italian Renaissance and at the Burgundy court – moves in virtual fashion towards the *Triumphal Arch*.

The most beautiful works that Dürer executed for Maximilian are the marginal drawings for the Emperor's prayerbook. Selected members of the Chivalric Order of St George, founded in 1469, were each to receive a printed prayerbook. Whether the ornamental drawings in the margins of the Munich prayerbook, which is printed on unusually expensive vellum, represent the illustrations to a personal, de luxe edition prepared exclusively for the Emperor, or whether they should be considered preliminary drawings for the printing block, remains a matter of dispute. Dürer embarked on the project in 1514. By the following year he had completed a total of 50 pages, 45 of them with fanciful figural borders. The marginal drawings are executed in just one colour, be it red, green or purple. Most striking of all is perhaps the verso of folio 41 (ill. p. 43), with the opening lines of Psalm 24: "The earth is the Lord's and the fullness thereof; the world, and they that dwell therein." Dürer includes a "savage" from the New World! A perceptive visual comment which reflects the hunger in Augsburg and Nuremberg for news from America, for whose distant shores so many of their merchants and adventurers had set sail, in search of the gold of the "Indians".

In 1513 and 1514 the Habsburg court employed Dürer on a project that had been running since 1502 – Maximilian's tomb. This enormous ensemble of over-lifesize bronze statues, intended for the chapel in his Wiener Neustadt castle, was eventually erected in the Hofkirche in Innsbruck. Hans Leinberger (1480/85 – after 1530) would translate one of the drawings contributed by Dürer into the sculpture of *Albrecht of Habsburg* (ill. p. 94).

Dürer was engaged on the refurbishment of the Nuremberg town hall for a whole ten years. His involvement began in the summer of 1516 with an expert opinion on a new decorative scheme for the council chamber. It would conclude in 1526 with the installation of the *Four Apostles* (ill. p. 77). In between lay the

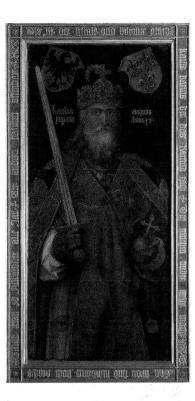

Emperor Charlemagne, c. 1512
Oil on panel, 190 x 89 cm
Nuremberg, Germanisches Nationalmuseum

Triumphal Arch for Emperor Maximilian I,
1515 (this impression from the Vienna revised re-edition of 1559)
Hand-coloured woodcut, 3.41 x 2.92 m
Vienna, Graphische Sammlung Albertina

Surviving records fail to tell us precisely when the Albertina impression was coloured in by hand, but on stylistic grounds it must have been considerably after the woodcut was first printed.

complete redecoration of the grand assembly hall, which played host to the glittering imperial court. In order to impress Maximilian's successor, Emperor Charles V, with paintings by Dürer, the Nuremberg authorities ordered virtually the whole of the 14th-century sculpture cycle to be knocked down. Dürer got down to work in the middle of 1521. For the north wall he envisaged Maximilian I in a triumphal car pulled by Virtues and more particularly the *Allegory of Calumny,* based on descriptions in antique sources of a famous painting by Apelles. The names of the assistants who executed the murals (destroyed in the firestorm of 1944) from Dürer's designs are not known. A few weeks later, work began on the exterior façade of the assembly chamber. From surviving documents it is evident that Dürer needed to spare no expense when it came to labour or materials, even gold leaf.

Outside his vast duties for the Emperor and the city authorities, did Dürer manage to find any time at all for anything else? Yes is the answer, as demonstrated above all by his graphic works. In 1511 Dürer brought out three substantial woodcut cycles – the *Large Woodcut Passion* (a single sheet cost around twelve *pfennigs* and one *heller,* about half a day's wages for a Nuremberg stonemason), the *Life of the Virgin* and the *Small Woodcut Passion* – and in 1513 a fourth, the *Engraved Passion.* Altogether, the four cycles total 85 sheets and represent a triumph of the reproducible image and of a seemingly boundless imagination. Between 1515 and 1518 Dürer also practiced etching on iron plates. Six such etchings survive, amongst them the enigmatic *Sheet of Studies with Five Figures (The Desperate Man)* (ill. p. 47), which has yet to be conclusively deciphered.

The years 1513 and 1514 also brought forth Dürer's so-called master engravings: *Knight, Death and the Devil* (ill. p. 51), *Saint Jerome in his Cell* (ill. p. 48) and *Melancholia I* (ill. p. 50). The precision of their engraving remained unsurpassed: "The three engravings, which in good prints have a silver sheen, are woven out of an infinite number of fine lines, [...] in whose indissoluble fabric the time invested is transformed into enduring art." (Johann Konrad Eberlein)

A number of art historians have postulated a connection between the three subjects: the Knight as a symbol of steadfast Christian faith, *Melancholia I* as a symbol of the dangers to art that lie in brooding meditation, and St Jerome – the saint, incidentally, whom Dürer drew more than any other – as the embodiment

The Great Triumphal Car, 1518
Pen and brown ink with watercolour,
45.5 x 250.8 cm
Vienna, Graphische Sammlung Albertina

The allegorical female figures were modelled on Andrea Mantegna's copperplate engraving of the *Dancing Muses* The horses also seem to draw inspiration from Albrecht Altdorfer's specimen impressions of 1517/18 for the *Triumphal Arch* woodcut.

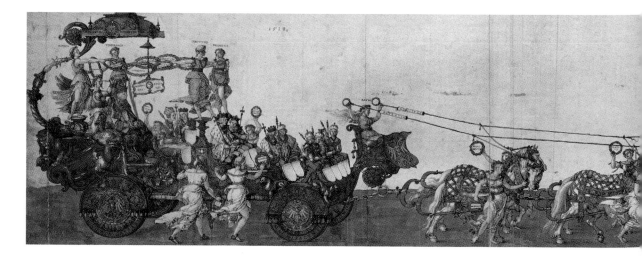

of divine revelation in seclusion. It has further been argued that the three master engravings, taken together with the 1504 engraving of *Adam and Eve* (ill. p. 83), make up a quartet illustrating the four cardinal humours. Thus the sanguine Adam and Eve are followed by the choleric Knight, by Melancholy herself and finally by the phlegmatic St Jerome. It is clear from the manner in which they were sold, however, that the prints were never marketed as a series.

St Jerome in his Cell appears the most straightforward in its iconography. The devout scholar and translator of the Vulgate edition of the Bible was considered the embodiment of the *vita contemplativa* and thereby also of humanist erudition. In the mid-16th century, Giorgio Vasari – not usually very tolerant of foreign artists – praised the artistry with which Dürer allowed the sunlight to fall through the bull's-eye window – an effect that in the Baroque era would impress none less than Rembrandt.

Knight, Death and the Devil – which Dürer simply called *Rider* – is the subject of widely diverging opinions. The protagonist of the picture, his visor raised, is looking down the path ahead. His profile is sharply drawn, his face darkly energetic. He seems heedless either of the skeletal figure of Death right beside him, holding out an hourglass containing the trickling sands of time, or of the Devil approaching from the rear. The fantastical scene is set in a ravine between rocky cliffs; a skull and a salamander can be seen on the ground. The dog pays no attention to this eerie medley of objects. He simply wants to escape with his master from the confines of the path and up to the castle at the top of the picture.

In 1936 the German art historian Wilhelm Waetzold felt compelled to appropriate the "Rider" for nationalistic ends: "Heroic souls love this engraving – just as Nietzsche did and just as Adolf Hitler does today. They love it because it is a picture of victory."

It is understandable that modern researchers should wish to distance themselves from such ideological misconstructions. A few years ago, indeed, Alexander Perrig claimed the very opposite: the knight in shining armour was in fact not a virtuous hero or victor at all. Rather, the fox-brush on his lance proclaimed the supposed Defender of the Faith to be a sanctimonious hypocrite, in German a *Fuchsschwänzler* (literally, "one with a fox's tail"). Here the author's attempt at demystification misses the mark: we need only think of Emperor Maximilian I,

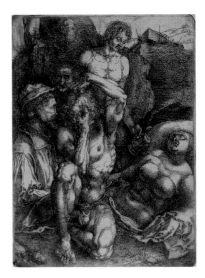

The Desperate Man, 1515 / 16
Etching on iron plate, 19 x 13.8 cm
Vienna, Graphische Sammlung Albertina

Dürer researchers have sought in vain to decipher the figures making up this sheet of studies. The half-length clothed man on the left has been variously identified as Dürer's brother Endres and as Michelangelo (the very Italian artist of whom Dürer thought so little!). What are the intentions of the naked man who has obviously had too much to drink and is now eyeing the similarly naked woman before him? The spectral face of the old man appearing in the rock recalls the god Saturn, as drawn by Dürer's pupil Hans Baldung Grien in 1516 (Vienna, Albertina). Equally enigmatic is the figure kneeling in the centre, who in 1871 inspired the title by which the etching is now known.

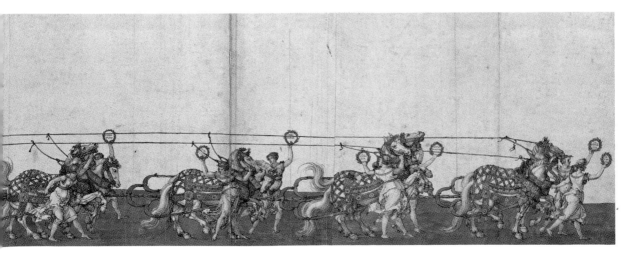

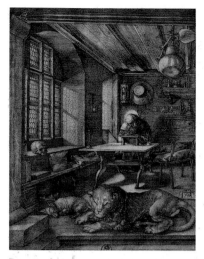

In 1499 the brothers Hans and Nikolaus Tucher commissioned Dürer to paint portraits of them and their wives. Each pair of paintings was hinged to form a diptych. The portrait of Nikolaus has long since disappeared, but this painting of his wife, whose father was master of the arsenal with the Nuremberg artillery, has survived.

The number "I" behind the title "Melencolia" held by a bat in the background still demands explanation. The most plausible solution remains the one offered by Panofsky, who interprets the engraving in the context of the three spheres of talent governed by Saturn: imagination, discursive reason and spiritual intuition. According to the writings of Dürer's own day, the artist fell into the first and lowest of these spheres.

who in 1498 adopted the fox-brush as the ensign of a cavalry contingent of 100 armoured knights – certainly not to identify as "sanctimonious hypocrites"!

Far more convincing than Perrig's highly tenuous interpretation remains the idea that the knight, a "devil of a fellow" in every respect, symbolizes the Christian for whom life is military service and who combats Death and the Devil armed with belief. In his *City of God,* St Augustine described the Christian existence as a pilgrimage through an evil world. The spiritual authority in Dürer's own day, Erasmus of Rotterdam (1466 or 1469 – 1536), had also made the Christian knight the subject of his *Enchiridion militis christiani* (The Manual of a Christian Knight) first published in 1503. Although the treatise only become more widely known after 1518, when a second edition was printed, it fits Dürer's engraving so well that the artist may have read it before this date. Dürer presents the man in the saddle both with death and decay and with the fortified castle, the citadel of God, the saving goal. The rider grips the reins and keeps his powerful horse in check – a symbol also for the restraint of the instincts and passions, and for a virtuous self-mastery that faces Death with composure and turns its back on the Devil. Formal inspiration for the horse may have come from Leonardo da Vinci, possibly via Giovanni Galeazzo di San Severino: son-in-law of the illustrious Lodovico Sforza, Duke of Milan and Leonardo's patron, Galeazzo had visited Nuremberg in 1502 as a guest of Pirckheimer.

Vasari's verdict is still valid today: *Melancholia I* is one of those works of art *che feciono stupire il mondo* – "that astounds the whole world". This "picture of pictures" has been analysed at greater length than any other work by Dürer – not just by art historians, but also by doctors, mathematicians, astronomers and freemasons alike. Much literature has been devoted to the small engraving, smaller than a sheet of A4, and many interpretations exist, above all with regard to the Neoplatonic content of the enigmatic scene. The magic square in the upper right-hand corner, any four of whose numbers come to the same sum of 34 whether added horizontally, vertically or diagonally, supposedly contains in its top row the day, month and year of Dürer's mother's death; what is certain is that the two numbers in the middle of the bottom row – 15 and 14 – yield the date of the engraving itself.

To understand this brooding, winged, heroine-like figure of a woman as the personification of the melancholic temperament is surely not mistaken. The putto, greyhound, tools and solid geometric figures represent firstly the creative possibilities of the human condition, and secondly the dangers that result when paralysis overtakes the power to act. The dark side of melancholy is also evoked by the bat-like creature bearing the title over a watery landscape in the background, and by the apocalyptic sign of a rainbow and a comet in the sky.

The sheet might thus also be a cryptic self-portrait, or at least a confrontation with one facet of Dürer's life as an artist. Other facets to Dürer present him as petit bourgeois, commercially minded and occasionally money-grubbing. In 1515 Maximilian I granted him a lifetime annuity. When Maximilian died in 1519 and his grandson ascended to the throne, it was uncertain whether this arrangement would be honoured. The coronation was to take place in Aachen in the autumn of 1520, and Dürer was determined to obtain confirmation of his stipend from Charles V in person. He attached himself to the delegation from Nuremberg that was taking the coronation regalia to the Lower Rhine. The plague carts, moreover, were once more rattling their way through the streets of Nuremberg. So he left the city, first for Aachen, then for the Netherlands, where Charles intended to pay his first state visit as Emperor. This time Dürer took his Agnes with him.

49

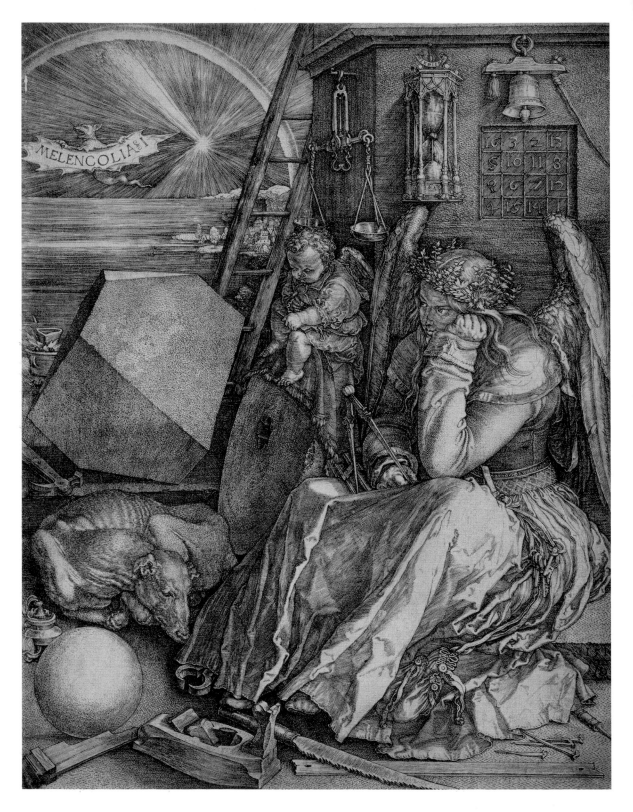

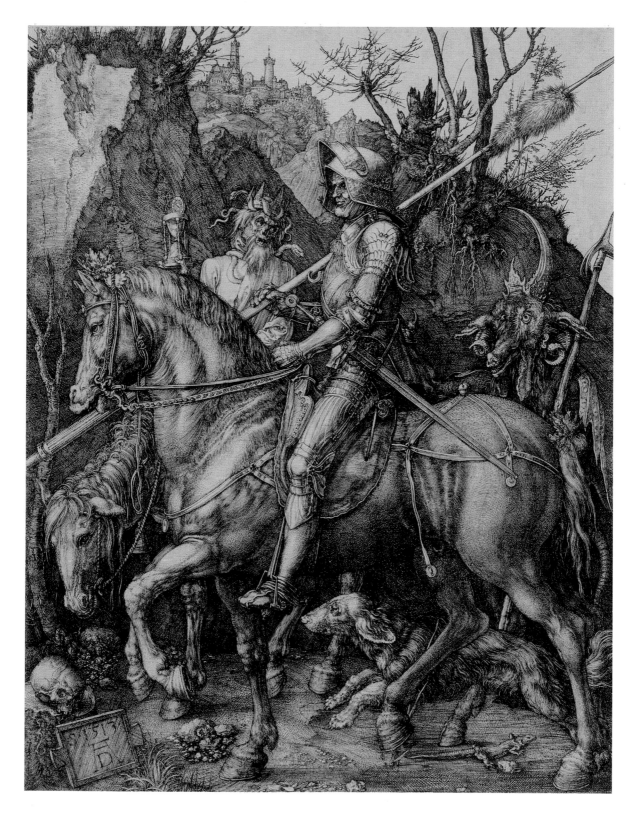

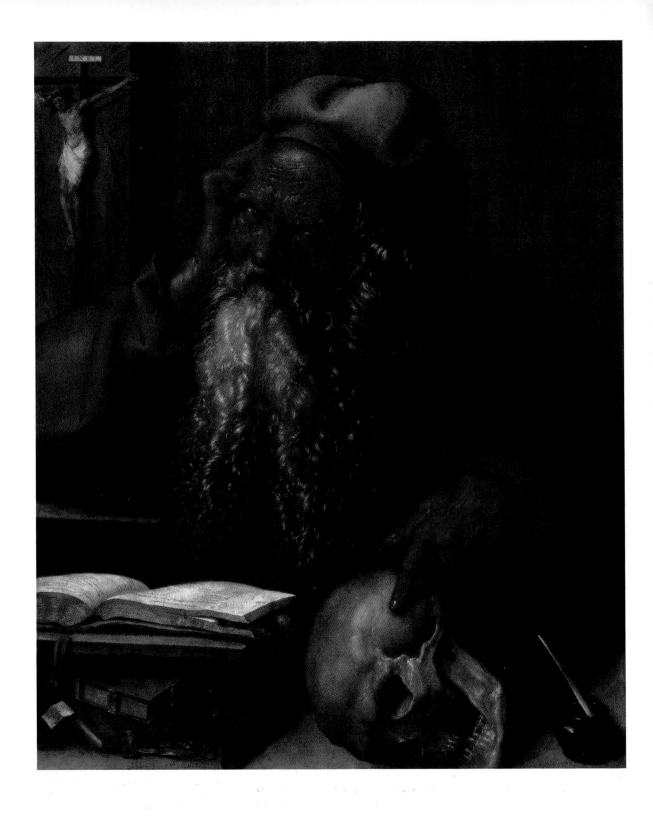

In the Netherlands

In the Museum of Ancient Art in Lisbon there hangs what is for many visitors and tourists an unexpected gem: a small panel of *Saint Jerome* (ill. p. 52) executed by Dürer in the Netherlands, the character study of an elderly scholar pondering the transient nature of this mortal life. As his model for the Church Father, Dürer used a 93-year-old Antwerp man, whose original portrait drawing was transformed across four further drawings into the magnificent, almost hyper-realistic bust of St Jerome. The panel derives a major part of its impact from the large skull portrayed in highly realistic detail in the lower right-hand corner, a symbol of asceticism and the mortification of the flesh on which the saint lays his finger. But is the man scrutinizing us from inside the frame really a saint? Representations of St Jerome during this period were frequently assuming a new, temporal dimension. The Church Father was increasingly identified with the secular patron of humanism and literature – a connection that may be meaningfully underlined by the exquisitely painted still life of the books in the lower left-hand corner. More and more, such images of devout intellectualism were finding their way – just like this one – into scholar's studies and private art collections.

No other Dürer painting is better documented. This is related to the fact that the artist kept a journal of his visit to the Netherlands, recording almost week for week not just information about the trip but also the impressions it made upon him. Although the original diary has since been lost, copies made in the 17th century mean that its contents have been preserved. Two of the artist's sketchbooks from this trip have also survived. They include, among many other drawings, the well-known view of *Antwerp Harbour* on the River Schelde rendered with a few incisive strokes of the pen (ill. p. 55).

In the summer of 1520 Albrecht Dürer started out from Nuremberg one last time. His destination was Flanders and Brabant, his purpose to visit the Emperor and the prosperous cities of the Netherlands, with their promise of lucrative commissions. Dürer and his wife Agnes set off on 12 July, a staid married couple carrying in their baggage all the graphic works in the artist's possession. On 2 August they reached Antwerp – an international centre of trade which had now overtaken the German imperial city of Nuremberg in terms of economic strength and was more important even than the queen of the Adriatic, Venice. Since the discovery of America on the other side of the great ocean, and since

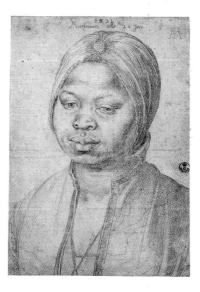

The Negress Katharina, 1521
Silverpoint drawing, 20 x 14 cm
Florence, Galleria degli Uffizi

Saint Jerome, 1521
Mixed media on oak, 59.5 x 48.5 cm
Lisbon, Museu Nacional de Arte Antiga

It was earlier thought that Dürer conceived his saint in response to a painting by Quentin Massys. It now seems to have been the other way round: the panel by the Antwerp master, executed by his workshop (Vienna, Kunsthlstorisches Museum), was inspired by that of his Nuremberg colleague.

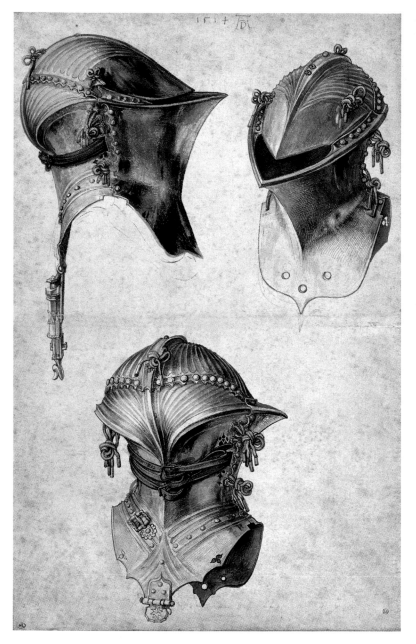

A jousting helmet for the **German Joust,** c. 1498
Pen and brown ink and watercolour,
42 x 26.5 cm
Paris, Musée du Louvre,
Département des Arts Graphiques

This carefully executed sheet, which may belong
to a slightly later date of c. 1501, is characterized
by its dazzling treatment of surfaces and the
astounding reflections on the polished metal.

ships had started bringing entire cargoes of treasure from the new continent
back to Europe, Lisbon and Antwerp had become the real gateways to the world.

In Antwerp the visitor was granted an enthusiastic and admiring reception
by his Netherlandish colleagues. On 5 May 1521, following one such gathering
in his honour, Dürer coined a new term that is still with us today: he namely
described one of Antwerp's leading masters, Joachim Patenier (1475 / 80 – 1524),
as a "good landscape painter".

Patenier made a speciality of sweeping panoramic vistas, sometimes known
as "world landscapes". Dürer may already have encountered these landscapes

at third hand at an earlier date, through the work of Simon Bening. One of the greatest book illuminators in his field, Bening was probably born in Ghent in 1483 and died in Bruges in 1561. In the opening decades of the 16th century, he illustrated a number of prayerbooks for Cardinal Albrecht of Brandenburg – whom Dürer also knew – with miniatures whose landscapes are clearly inspired by Patenier. Bening's influence on early 16th-century book illumination in Germany, and in particular on the Glockendon workshop in Nuremberg, was enormous. If Dürer had already come across Patenier's innovations in landscape painting, as conveyed via Bening, he would have been all the more eager to visit the master himself. In Antwerp, the two artists subsequently developed something akin to a friendship.

In many of his diary entries, Dürer describes how honoured he is by all the attention being heaped upon him. But fame did not blind him, and the lavish meals to which he and sometimes also his wife and maid Susanna were invited did not keep him solely in one place. At the beginning of September he paid a visit to the palace in Brussels, whose rooms housed wonderful and exotic objects that were the talk of Europe. On display were the gifts that the Spanish military commander Hernán Cortés had brought back from his conquests in Mexico and presented to Emperor Charles V: weapons, jewellery and religious objects, marvels of Indian culture extorted by the conquistador from the Aztec chief in Tenochtitlán, so utterly foreign that they might have come from another planet. Dürer quickly got over his "culture shock" and admired the outstanding craftsmanship of these works from afar. He also reflected on their exorbitant price: to make the same amount of money, he sighed, he would have to paint 400 altarpieces!

In Brussels the tourist from Nuremberg also observed and drew lions in the Ducal Zoo and admired the large meteorite in the Count of Nassau's Cabinet of Curiosities. The artist was always interested in the unusual: his 1515 drawing of a rhinoceros is just one example (ill. p. 55). A short while earlier, ships returning from the Indian Ocean had docked at Lisbon – with a rhino on board. A German merchant who just happened to be in Lisbon made a sketch of the animal, which had never before been seen in Europe. His drawing reached Nuremberg weeks later, and Dürer copied it – with numerous fanciful additions. The real rhinoceros was sent on to Rome as a present for the Pope, but perished in a shipwreck.

Dürer did not find rhinoceroses in the Netherlands, and nor did he see the whale stranded in Seeland. When he finally arrived after a hair-raising trip in a sailing boat, the tide had already carried the marine giant back out into the open sea. Instead, he met "exotic" members of his own species, whom he captured with his pen with admirable *noblesse,* free from any racial arrogance. Dürer thus draws the likeness of *The Negress Katharina* (ill. p. 53), a servant in the household of the Portuguese factor João Brandão, with the same psychological empathy and sympathy that he brings to other portraits, executed during this same trip, of expatriate Germans: the Danzig merchant *Bernhard von Reesen* (ill. p. 57), who died of the plague in October 1521 at the age of 30, and the tax collector *Lorenz Sterck* (ill. p. 56). These portraits surpass if possible even those painted by Hans Holbein the Younger (1497 / 98 – 1543) of German merchants living in London.

Dürer was very much the businessman in Antwerp. He knew that it was necessary not only to sell works, but sometimes also to give them away. The city on the River Schelde was home to a number of Portuguese factors, influential and wealthy merchants. The above-mentioned João Brandão was the most

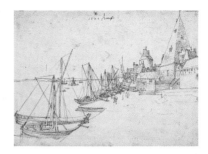

Antwerp Harbour seen from the Schelde Gate, 1520
Pen and brown ink, 21.3 x 28.8 cm
Vienna, Graphische Sammlung Albertina

Rhinoceros, 1515
Pen drawing, 27.4 x 42 cm
London, The British Museum,
Department of Prints and Drawings

Portrait of Tax Collector Lorenz Sterck, 1521
Mixed media on panel, 50 x 36 cm
Madrid, Museo Nacional del Prado

The date given in the inscription is difficult to
decipher and could be 1521 or 1524. On stylistic
grounds, the earlier date seems more likely.

senior of them all, with Rui Fernandes de Almada acting as his right hand. The
latter had enjoyed a humanist education and had also spent time in Nurem-
berg in 1519. To these important men Dürer generously gave out whole series of
his graphic works. They more than returned his gesture! Rui Fernandes, for
example, gave the worthy Agnes a little green parrot – still a valuable rarity in
those days. Wine, oysters, a cask of candied sugar, marzipan, Indian quills, Indian
nuts, faience, more parrots, rings and gratuities found their way to the two
tourists during these weeks in the Netherlands. While these may not have been
Aztec treasures, they nonetheless represented in some cases costly and exciting
souvenirs from abroad.

Dürer responded handsomely in his turn. To Rui Fernandes he gave the
most precious thing he produced during his whole time in the Netherlands:
the same panel of St Jerome that today hangs in Lisbon. This virtuoso painting –
which remained in the Netherlands with its owner right up to 1548 – rapidly
came to serve Netherlandish painters as a supreme example of Dürer's art.
No other panel by the Nuremberg artist was copied so often in the 16th century.
The number of more or less exact replicas and variations has been estimated
at around 120!

Dürer did not meet with success everywhere in the Netherlands, however.
One of his most painful experiences occurred on 6 June 1521, when he went back
to Mechlin. He was visiting Arch-Duchess Margaret of Austria (1480 – 1530),
daughter of Maximilian I and general governor of the Netherlands since 1507.
Dürer owed her an enormous debt of thanks, as she had used her influence with
Emperor Charles V to ensure that his annuity would continue to be paid. He
presented Margaret with one of his portraits of Maximilian from 1519 – we do
not know which. He then had to suffer being informed that it did not please!

There was something worse, however. In the Netherlands, probably on his
excursion to see the whale amongst the brackish waters of the Seeland coast,
Dürer contracted an illness from which he never recovered. He was plagued by
fever, nausea, fainting and headaches – probably the symptoms of chronic ma-
laria. From now on he would suffer regular bouts of fever; from now on con-
sultations with doctors would form part of his everyday life.

Something existential also happened during the Netherlands trip. In 1521
Dürer received the erroneous news that the reformer Martin Luther (1483 – 1546)
was dead. He subsequently wrote in his diary a moving lament: "And if we
should lose this man, who has written more clearly than anyone in one hundred
and forty years, and to whom Thou has given such an evangelical spirit, we
pray Thee, O Heavenly Father, that Thou give again Thy Holy Spirit to another,
that he may gather together anew from all parts Thy holy Christian Church, so
that we may all live in Christian unity, and so that from our good works all un-
believers, such as the Turks, the heathens and the Indians, shall turn to us and
embrace the Christian faith."

Against this background, it is time that we considered Dürer as the painter of
religious works of art.

Portrait of Bernhard von Reesen, 1521
Mixed media on oak, 45.5 x 31.5 cm
Dresden, Staatliche Kunstsammlungen,
Gemäldegalerie Alte Meister

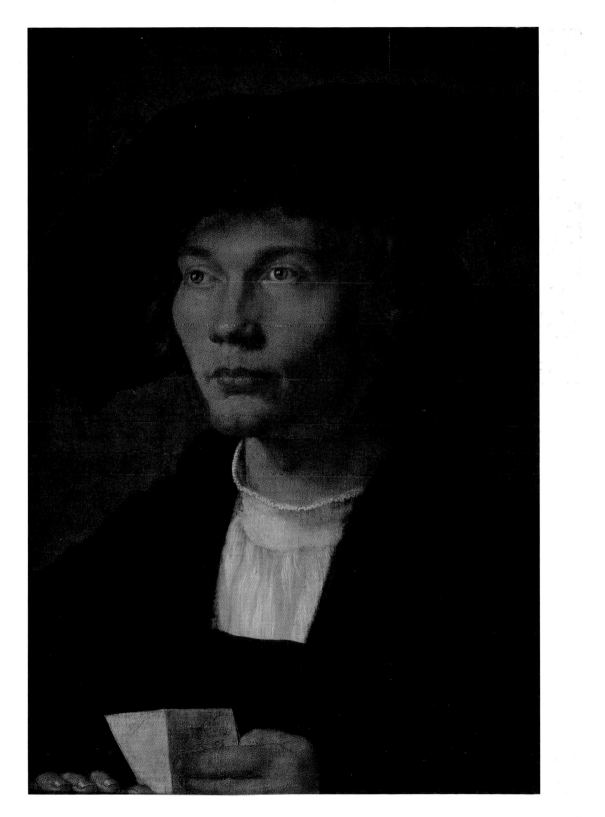

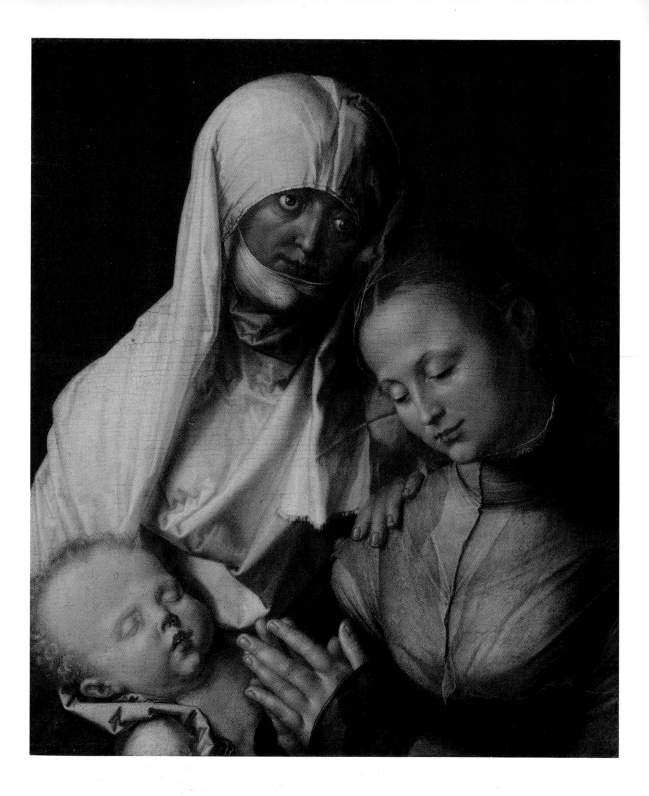

Dürer and religion

Dürer was a devout Christian. He was of course no saint, and in his own eyes he was a man heavily burdened with sin. He grew up in a society permeated by religion at every level. In the middle of the 15th century, the Augsburg chronicler Burkhard Zink wrote: "dann iedermann wolt gen himl" (everyone strives towards Heaven). There were many paths to salvation: charitable donations, the study of edifying literature, a naïve belief in miracles as well as serious humanist scholarship, and participation by the lay community in the ecclesiastical life of their parishes and in official confraternities. In short, Germany's cities found themselves stylised into extensions of God's realm. In this very boom in religious devotion, however, crisis loomed. The inflationary growth in the veneration of saints became symptomatic of an externalisation of faith. Saints became a fixture of everyday life, revered, loved and also reviled, should they fail to prove effective. Just as masses, pilgrimages, endowments and donations were supposed to guarantee eternal salvation, so God's favour could also be curried with financial expenditure on altarpieces and works of art.

That Dürer did not escape this mindset is clear from his earliest graphic works and devotional panels onwards, and in particular from the Venetian-influenced Madonna paintings discussed in Chapter 1. Another example is the Vienna *Virgin and Child* of 1512 (ill. p. 61), which in its palette and composition radiates an unprecedented harmony. Devotional panels continued to form part of the repertoire of the Nuremberg master. In 1516, for example, he made a set of paintings of the Apostle's heads. Two – *James the Elder* (ill. p. 60) and Philip – are today housed in Florence: masterpieces of finely detailed painting, they are the only survivors of an unfinished series of the twelve disciples. *St Anne with the Virgin and Child* (ill. p. 58), today in New York, is dated to 1519; a study for the face of St Anne is unmistakably based on Dürer's wife, Agnes. After his return from the Netherlands, the Nuremberg master devoted himself intensively to a *sacra conversazione*, a pictorial genre originating from Italy in which the Virgin is shown in the quiet, contemplative company of a number of saints. The final composition was never executed, but a number of preparatory drawings have survived, including the suggestive study of St Apollonia in Berlin (ill. p. 81). Dürer's last Madonna painting, meanwhile, another magnificent *Virgin and Child with the Pear* in Florence (ill. p. 59), arose at a time when Nuremberg had already embraced Luther's Reformation.

Virgin and Child with the Pear, 1526
Mixed media on panel, 43 x 32 cm
Florence, Galleria degli Uffizi

St Anne with the Virgin and Child, 1519
Mixed media on panel, 60 x 49 cm
New York, The Metropolitan Museum of Art
(Bequest of Benjamin Altman)

The doctrine that St Anne – the mother of the Blessed Virgin Mary, who was free from all original sin – had given birth to her daughter as the result of a virginal conception, had been gaining popularity since the last quarter of the 15th century. The veneration of St Anne spread rapidly across Europe and founds its expression in art in the representation of the three generations: St Anne, the Virgin and the Infant Christ.

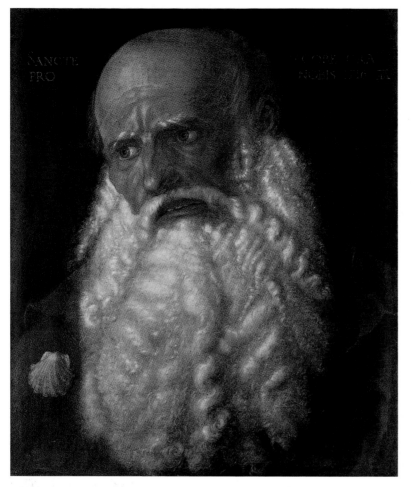

The Apostle James the Elder, 1516
Painting on canvas, 46 x 38 cm
Florence, Galleria degli Uffizi

The powerful city of Nuremberg, a centre of international trade, industry and banking and a focus of humanistic thought, domestic religiosity and patrician culture, officially embraced the Lutheran confession in 1525. The council successfully sought to avoid any radical and even iconoclastic excesses. It therefore adopted the same stance as Luther himself. The more that Luther grew into his role of reformer, the more forcefully he denounced the popular faith in miracles, saints and relics and the more suspiciously he regarded works of religious art. But he did not agree, as he said himself, with the destruction of images. Luther even described some subjects, in particular allegorical and Old Testament themes, as particularly instructive and worthy of imitation. He prized St Jerome for his contribution as a scholar and Bible translator. He was also tolerant of the cult of St Anne, the mother of the Virgin Mary. As a miner's son, Luther was familiar with St Anne as the patron saint of miners and was perhaps sympathetic to her for this reason.

In terms of volume, Dürer's painted œuvre is dominated by portraits and private devotional images. The relatively few altarpieces that he created were destined for side altars or smaller chapels of a more private nature – a case in point is the *Feast of the Rose Garlands* (ill. p. 62). Yet it is in such altarpieces – where

Virgin and Child, 1512
Mixed media on panel, 49 x 37 cm
Vienna, Kunsthistorisches Museum

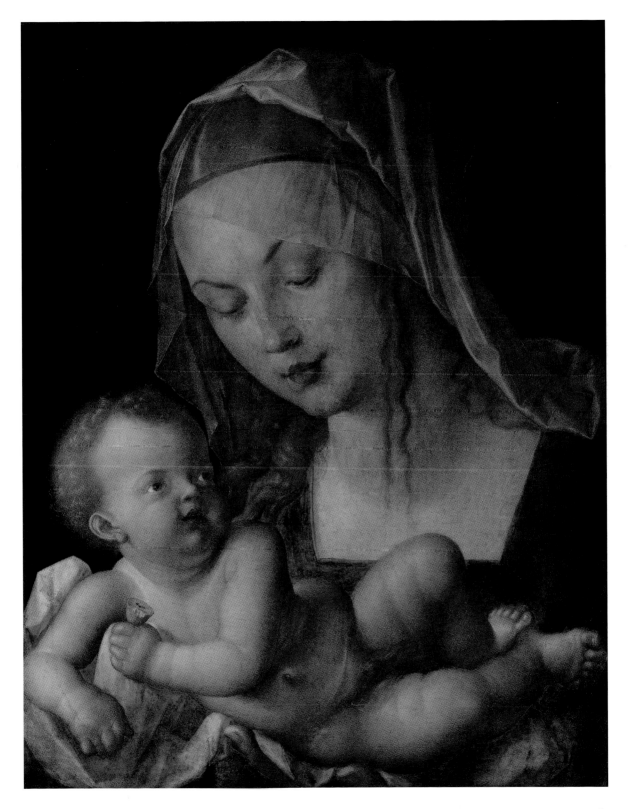

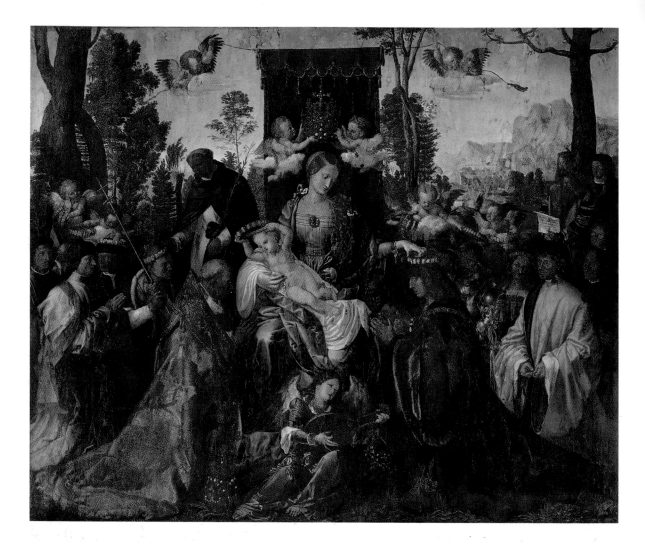

The Feast of the Rose Garlands, 1506
Mixed media on poplar, 162 x 194.5 cm
Prague, National Gallery

PAGE 64:
The Seven Sorrows of the Virgin, c. 1496 – 1498
Mixed media on softwood, reconstruction of
the original format c. 190 x 135 cm
Munich, Bayerische Staatsgemäldesamm-
lungen, Alte Pinakothek (the central *Mother
of Sorrows*) and Dresden, Staatliche Kunst-
sammlungen, Gemäldegalerie Alte Meister
(the remaining panels)

religious figure painting, portrait, self-portrait, landscape and minutely detailed
plant studies fuse into a perfect symbiosis – that his achievement as a painter
reaches its pinnacle. Moreover, Dürer's series of altarpieces also mark a cardinal
change: the folding polyptych of the Middle Ages gives way to the single-panel
altarpiece of the Renaissance! The most progressive example in this respect is
the *Landauer Altar* (ill. p. 68) commenced in 1508 – celebrated by art historians
as the first "Italian *pala*" north of the Alps.

Whether certain of Dürer's works were intended as altarpieces remains open
to question. A case in point is *The Seven Sorrows of the Virgin,* whose panels are
today divided between museums in Munich and Dresden (ill. p. 64).
All we know of the Munich panel is that in 1803/04 it formed part of the estate
of Kloster Benediktbeuern. The provenance of the Dresden panels, on the other
hand, can be traced back to 1588, when they were purchased by the Elector of
Saxony from the estate of Lucas Cranach the Younger. But where the work was
originally displayed, and who commissioned it (possibly Frederick the Wise),
is still unknown. The subject of the panel and the absence of any painting on the

Adoration of the Magi, 1504
Mixed media on panel, 100 x 114 cm
Florence, Galleria degli Uffizi

The painting originally hung in Wittenberg palace church. Its somewhat ostentatious character (take, for example, the rider in the background in the pose of a jousting knight) implies, however, that it served less as an altarpiece than as a celebration of Christian humanist regency.

reverse imply that it was originally mounted not on an altar but on the pillar of a church, as an object of quiet contemplation.

The *Adoration of the Magi* (ill. p. 63), painted in 1504 for Frederick the Wise, was also intended for a more intimate devotional setting. Described as "the first picture in German art to show perfect clarity" (Heinrich Wölfflin), the harmonious proportions of the figures, the perspective construction and the rearing horse in miniature scale in the background lend the composition an impressively classical sense of equilibrium, fully able to compete with Italian Renaissance painting.

The Martyrdom of the Ten Thousand (ill. p. 65), another commission from Frederick the Wise, was destined for a relics chamber in the Elector's Wittenberg palace church. With its host of small figures and its richly varied landscape, this portrayal of the massacre of 10,000 early Christian soldiers and their leader Achatius on Mount Ararat kept Dürer occupied until well into 1508. When news reached him of the death (on 2 February 1508 in Vienna) of Konrad Celtis, he

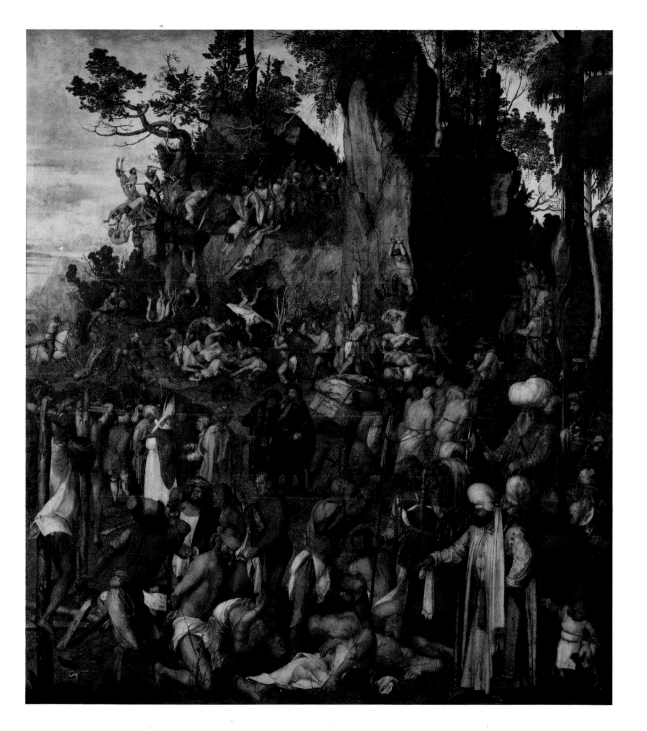

The Martyrdom of the Ten Thousand, 1508
Mixed media on canvas, 99 x 87 cm. Vienna, Kunsthistorisches Museum

The painting was destined to adorn the relics chamber in the Wittenberg palace church,
in which Elector Frederick the Wise of Saxony had assembled a vast collection of relics, including
some of the remains of the ten thousand martyrs.

DER ALTAR · GEBURT CHRISTI

DER HL. EUSTACHIUS

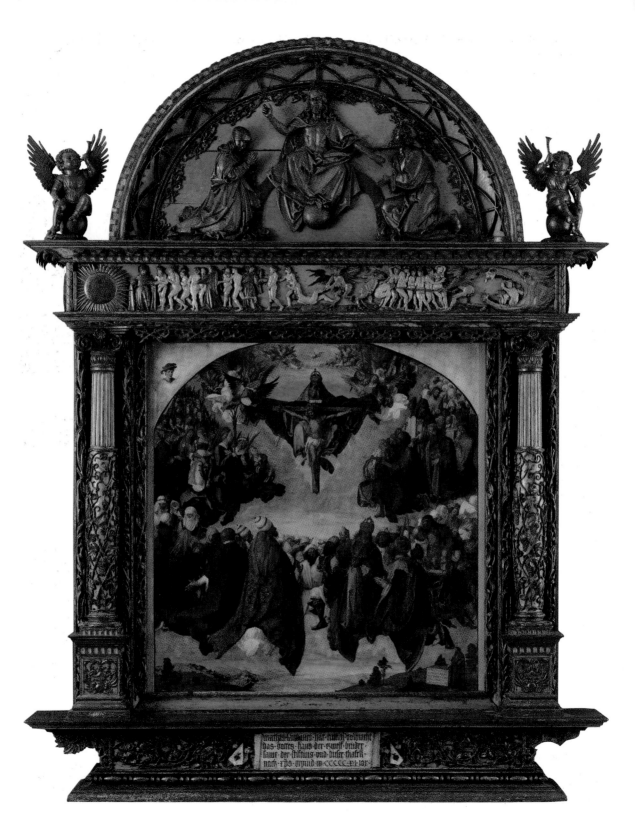

was therefore able to incorporate the figure of his former friend beside his own in the middle of the scene.

Let us now review the undisputed altarpieces by Dürer the painter. The *Paumgartner Altar* (ill. pp. 66/67) stood in St Catherine's church in Nuremberg. Only the three inner faces of this triptych, depicting the Nativity (in the centre) and two saints (one on either wing), are by Dürer. The altarpiece, which commemorates the Nuremberg patrician Martin Paumgartner (d. 1478) and his wife Barbara, née Volckamer (d. 1494), was commissioned by their son Stephan to mark a pilgrimage that he made to the Holy Land in 1498. Stephan Paumgartner seems to have been particularly impressed in Palestine by the birthplace of Christ, which may also explain the choice of the Nativity for the centre panel. Stephan himself probably appears in the figure of St George on the inside of the left wing, with – according to one 17th-century source – his brother Lukas Paumgartner in the guise of St Eustace as his pendant on the right.

There is a striking difference between the centre panel, constructed in exaggeratedly geometric perspective and colourfully populated by the protagonists of the first Christmas, supplemented by little angels and the diminutive figures of the donor family, and the outer wings with their two monumental donor-saints standing against a dark background. This contrast has been variously interpreted as illustrating the conflict between the Netherlandish-German heritage of the Late Gothic and innovatively Italian figuration on a large scale. More instructive than such stylistic considerations, however, is the pointer to a hidden epiphany: the saints on the outer panels are namely both facing inward. Even without the wings of the altarpiece being angled slightly forwards, as was the convention, both figures are looking directly at the central scene, which, precisely in its discrepancy of scale, reveals itself as the "mental image" they are meditating upon.

The four surviving panels of the *Jabach Altar* (ill. pp. 69 – 71) are parts of two wings sawn apart. At what date the centre panel became separated from the wings, and precisely when these latter were cut up, remains unknown, as does the fate of the centre panel.

The iconography of the scene on the exterior of the wings is unusual and is not found before Dürer. We are shown Job sitting resignedly on the dung-heap, while his wife empties a bucket of water over his head. To the right, a drummer and a shawm-player are making music on a rise in the foreground. The trials of Job are illustrated in the background: on the right, a band of Chaldean raiders are stealing his camels, and behind them three riders are killing his servants; on the left, we are shown the burning ruins of a house in which all Job's children have perished. A man can be seen running to deliver the ill tidings.

It is possible that the Jabach Altar was commissioned by Frederick the Wise for the chapel of a bathhouse above a mineral spring. The bucket being emptied over Job might hence also be an allusion to therapeutic spa treatments. This thesis is supported by related illustrations in an edition of Petrarch's *Remedies for Fortune Fair or Foul* published in Augsburg in 1532, more specifically in the chapter on bathing as a cure for illness. The two minstrels next to Job are correspondingly trying to comfort the long-suffering Job with their own "music therapy".

A bathhouse is by no means the only possible context for such references to healing. Job – whose seated pose recalls that of an "afflicted Christ" – was also called upon for protection in times of the plague. In this respect, the Jabach Altar may represent an echo of the plague epidemic that is recorded to have swept

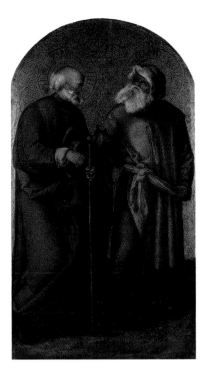

Saint Joseph and Saint Joachim,
c. 1503 – 1505
Mixed media on limewood, formerly the inside of the left wing of the Jabach Altar, 99 x 54 cm
Munich, Bayerische Staatsgemäldesammlungen, Alte Pinakothek

PAGES 66/67:
Paumgartner Altar, 1498 (according to the latest research; previously dated around 1502)
Mixed media on limewood, 157 x 248 cm
Munich, Bayerische Staatsgemäldesammlungen, Alte Pinakothek

Although Dürer was probably awarded the commission in 1498, it is unlikely that the work was actually executed that same year. The suggestion that the flourish on Joseph's lantern might – when read as a "2" – indicate the date 1502 has certain elements in its favour.

PAGE 68:
Landauer Altar, 1511
Mixed media on limewood,
135.4 x 123.5 cm (panel),
284 x 213 cm (frame)
Vienna, Kunsthistorisches Museum (the *All Saints* panel) and Nuremberg, Germanisches Nationalmuseum (the original aedicule-type frame)

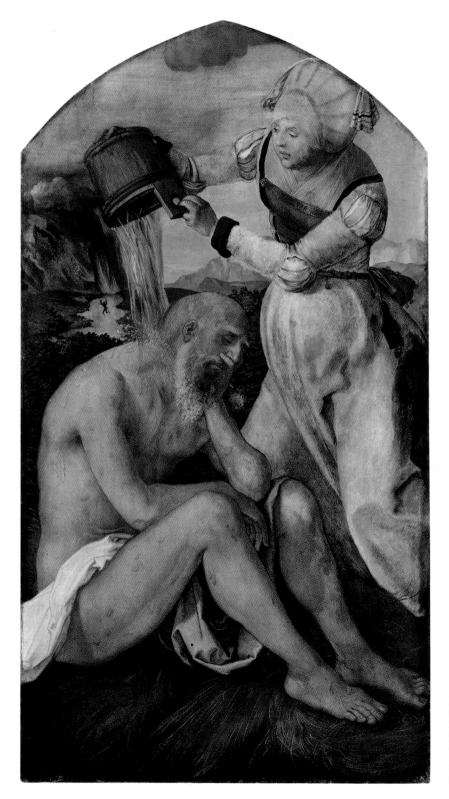

Job and his Wife,
c. 1503–1505
Mixed media on limewood,
formerly the outside of the
left wing of the Jabach
Altar, 96 x 51 cm
Frankfurt am Main,
Städelsches Kunstinstitut

Piper and Drummer,
c. 1503 – 1505
Mixed media on limewood,
formerly the outside of the
right wing of the Jabach
Altar, 94 x 51 cm
Cologne, Wallraf-Richartz-
Museum

Matthias Grünewald
St Cyriacus, panel from one of the
fixed wings of the *Heller Altar,*
c. 1509 – 1512,
Tempera (grisaille) on fir, 98.8 x 42.8 cm
Frankfurt am Main, Städelsches Kunstinstitut

Heller Altar, 1509
Reconstruction of the altarpiece with wings
open, with a copy of the centre panel by Jobst
Harrich (c. 1614)
Mixed media on panel, c. 190 x 260 cm
Frankfurt am Main, Historisches Museum

Germany between 1503 and 1506. The use of a gold ground – unusual even in its own day – may possibly indicate that the missing centre of the altarpiece was a time-honoured picture of a saint thought to have miraculous powers, as in the church in Wittenberg palace, or a reliquary in the shape of a figure standing in front of an identical gold ground.

The execution of the *Heller Altar* (ill. p. 73) was overshadowed by Dürer's ongoing battle with the patron to extract a larger fee than the one originally agreed. In the middle of 1507 Jakob Heller (around 1460 – 1522), a wealthy cloth merchant and a councillor from Frankfurt am Main, commissioned the Nuremberg master to execute a large altarpiece with its wings painted on both sides. It was intended as a gift for the Dominican church in Frankfurt and took as its central liturgical subject the triumphal Assumption and the Coronation of the Virgin (Mary also personifying *ecclesia,* the Church as an institution).

Dürer delivered the main bulk of the pictures making up the altarpiece in 1509: the centre panel showing the Assumption and Coronation of the Virgin, and the folding wings depicting on the inside the donors and, above them, their patron saints St James the Elder and St Catherine, and on the outside an Adoration of the Magi and individual saints – all executed in grisaille. Matthias Grünewald (c. 1475/80 – 1528) painted four additional fixed wings, also in grisaille, depicting further figures of saints (ill. p. 72).

The centre panel, portraying the Apostles gathered around the Virgin's empty tomb within a sweeping panoramic landscape, with the artist himself standing in the middle ground holding a tablet bearing his signature, was acquired by Maximilian I of Bavaria in 1614 and removed to his Munich palace, where it was subsequently destroyed in a fire of 1729. An impression of the painting's outstanding quality can only be gained from the copy executed by Jobst Harrich at the time of purchase. This impression is reinforced, however, by the eighteen famous preliminary drawings that also survive. Of these, the study of an apostle's hands has become famous the world over. Popularised under the title of *Praying Hands* (ill. p. 78), it has been all too often reduced to a devotional accessory for the religious masses. The hands were originally part of a preliminary drawing that also showed an apostle's head. They were later cut out from the rest of the sheet, allowing them to become an autonomous object of veneration.

In 1508, while still working on the *Heller Altar,* Dürer was commissioned by the wealthy Nuremberg councillor and merchant Matthäus Landauer (d. 1515) to execute an altarpiece for the All Saints' chapel in the Zwölfbrüderhaus (House of the Twelve Brethren). This was an almshouse that Landauer had founded for twelve elderly, upright artisans, who had fallen upon hard times through no fault of their own.

The donor was insistent that the painting should be as lavish as possible. It was to contain large amounts of gold leaf, and it was to be housed in a magnificently decorated wooden frame that would adhere it visually to the chapel wall. For the purposes of the contract, Dürer completed a drawing of both painting and frame even before 1508 was out, but it was 1511 before the ensemble was finished. The single-panel altar hung in the All Saints' chapel for which it was designed until 1585 (ill. p. 68).

The so-called *All Saints* altarpiece represents a work of great painting not just within the artist's own œuvre but in the history of art as a whole, yet its interpretation remains the subject of dispute even today. Any proposed explanation can only carry weight if it takes into account the overall decorative pro-

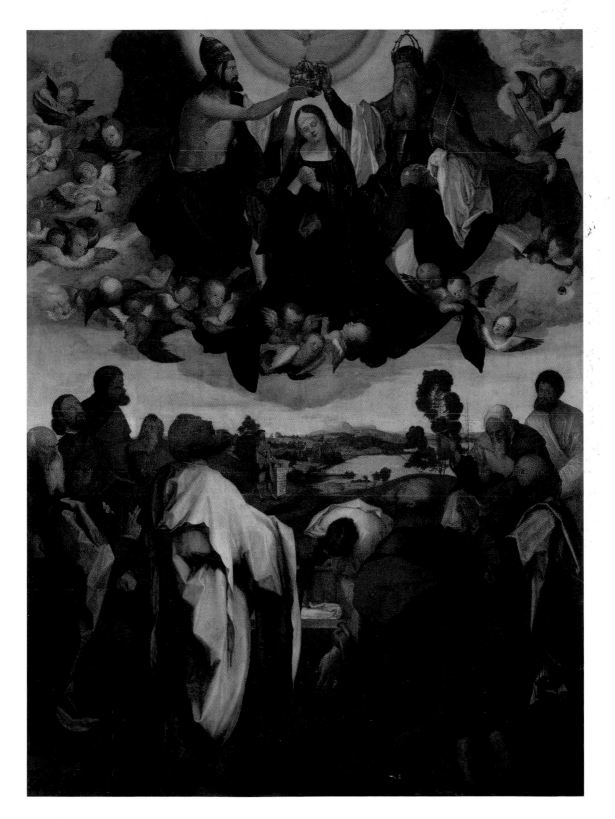

Head of an Apostle wearing a Cap, 1508
Brush in grey ink with a grey wash, heightened
with opaque white, on greyish-green prepared
paper, 31.6 x 21.2 cm
Vienna, Graphische Sammlung Albertina

The striking character of this sheet derives from
the highly pronounced features of the subject's
face. The drawing represents a preliminary
study for the head of the Apostle in the right-
hand background of the *Heller Altar.*

gramme of the chapel as it originally was, including the stained-glass windows
which Dürer also designed for the chapel and which were destroyed in the last
war. We only have room here for a few observations.

As appropriate for an All Saints' chapel, the altarpiece depicts the Adoration
of the Holy Trinity. The highest celestial realm is dominated by the Trinity.
Immediately below, in the central plane, follow the hosts of saints led by the
Virgin and St John the Baptist. Facing each other in the lower celestial realm are
the ecclesiastical and secular estates, whereby the clergy is led by not one pope
but two. This surprising inclusion of a second pontiff has been interpreted as a
warning of a schism that, as the painting was under execution, seemed once
more pending. The identity of the golden knight forming the glittering centre of
the secular estates is revealed by a coat of arms on his badge. He is the patron's
son-in-law, Wilhelm Haller, a commander-in-chief of the imperial forces (and
something of a Bohemian for his day).

Fanatical utopians, rabble-rousers and other agitators were announcing
during these years their fantastical visions of disaster and redemption. The call
for reform and renewal was everywhere to be heard. Many people associated the
idea of an eschatological knight and saviour with the person of Emperor Maxim-
ilian I, who would lead the Empire and Church to peace. It is proposed in the
more recent literature that Dürer – himself easily persuaded by any kind of
prophecy – wanted to give pictorial expression to such a utopian dream. The
renewal of a unified Christendom was to be the motto. Such a renewal was to
be expected not from Rome and the church of the pontiffs, however, but from
the regent of the Empire. It is for this reason, so it is argued, that Dürer portrays
the Emperor at the front of the secular estates as similar in both type and phy-
siognomy to God the Father. The head of the Empire comes into metaphysical
contact with the head of Creation.

There is much evidence to suggest that at least the basic thinking behind
this interpretation is correct. With what enthusiasm Dürer must have greeted
the appearance of a "prophet", Martin Luther, who would set this reform in un-
stoppable motion, for the good of Church and Empire! Dürer's religious stance
was influenced by the sermons of Johann von Staupitz, vicar general of the Au-
gustinians and a friend and mentor to Luther. Staupitz preached in Nuremberg
in 1512, 1515 and 1517, and Dürer presented him with numerous copperplate en-
gravings and woodcut series. Dürer's sympathy for the new teachings in the first
phase of the Protestant movement in Nuremberg is illustrated by two celebrated
passages in his writings. The first occurs in a letter to Spalatin, chaplain to the
Saxon court, dating from the beginning of 1520: Spalatin is requested to ask the
Elector to take up Luther's cause and to protect him. The second is the "lament
for Luther" of 21 March 1521, which he wrote – as we saw in the previous chapter
– in the journal he kept while in the Netherlands.

Between 1521 and 1524 Dürer undoubtedly belonged to the party that wel-
comed the religious reforms. From 1525, however, the year that saw the peak and
collapse of the peasant's war, the artist can be seen to distance himself somewhat
from the new movement, even if he did not go as far as his friends Pirckheimer
and Christoph Scheurl, who turned away from Luther altogether.

In 1524 certain radical tendencies surfaced in Nuremberg before the muni-
cipal authorities managed to quash them. A number of Dürer's pupils and jour-
neymen were involved. January 1525 subsequently saw the famous prosecution
of the "godless painters". Jörg Pencz, a "servant" in Dürer's house, and Dürer's
pupils Hans Sebald and Barthel Beham were amongst them. The artists were

Portrait of a Cleric, 1516
Mixed media on panel, 41.5 x 33 cm
Washington, National Gallery of Art
(Samuel H. Kress Collection)

According to one source, the man in the
painting – characterized as a clergyman by
his clothing – represents Johann Dorsch,
priest of St Johann's church. More recently
the sitter has been identified with the later
Zurich reformer Ulrich Zwingli. Both sug-
gestions are unconvincing, however.

communist and anarchist in their views. All three were banished. In May Dürer
was obliged to suffer the arrest of his best form-cutter, Hieronymus Andreae,
who had spoken out in support of the peasant uprisings. Reports of the banning
and despoiling of images issued from numerous cities. Dürer must have been
profoundly shocked by the news of vast numbers of works of art being destroyed.

These chaotic circumstances found their artistic counterweight in that
incomparable achievement of European painting, *The Four Apostles* (ill. p. 77).
When Dürer presented the finished work to the council of his native city of
Nuremberg in September 1526, he did so with the request that it should be hung
"in his memory" in the Town Hall. For the next 100 years the two panels enjoyed
pride of place in the upper council chamber, but in 1627 they were taken to
Munich as a result of pressure from Bavarian Elector Maximilian I. They were
an expression – new in Germany – of an artistic pride and at the time of their ex-
ecution were nothing short of a religious beacon!

The disposition of their two extreme verticals is unusual. Two panels of
identical dimensions come together in such a way that a mental space can be

Portrait of Johann Kleberger, 1526
Mixed media on limewood, 36.7 x 36.6 cm
Vienna, Kunsthistorisches Museum

Four emblems occupy the spandrels between
the painted portrait medallion and the square
frame. Below left, Kleberger's coat of arms,
below right his figurative crest; above right,
Dürer's monogram and the date; and above
left a patch of gold paint, in which six stars are
combined with the symbol for the zodiacal sign
of Leo.

The Four Apostles, 1526
Mixed media on limewood, each 204 x 74 cm
Munich, Bayerische Staatsgemäldesammlungen,
Alte Pinakothek

sensed and visualized between the two halves. Not for no reason was it long
thought that Dürer must have intended to execute a central panel, as in a trip-
tych. However, that was not the case.

Four holy pioneers of the faith, from left to right St John (the apostle and
Evangelist), St Peter, St Mark (an Evangelist but not an apostle) and St Paul, rise
like columns the full height of the panels, filling the pictorial space with the
solidity of monuments. Their contemplative poses are probably inspired by the
saints in Mantegna's San Zeno altarpiece (1457–1459) in Verona, or by works by
Giovanni Bellini, such as the side sections of the altar in the Sacristy of the Frari
church in Venice (ill. p. 16). Dürer's imposing figures champion the Gospel
truth, which they defend from all threats and sectarian exegesis. This is also the
message of the inscription that appears in calligraphic writing in a narrow strip
beneath the figures, a verbal "plinth" which also ties the two panels together.

On the left, Jesus's beloved disciple, St John, is portrayed as a youthful figure
who is inclining his head as he reads from the open book which he is holding
in his hands. From the saturated harmony of John's red cloak, the eye travels
to Peter, who wears a somewhat morose expression. Only the gold of his key
advertises his role as Christ's representative on earth. First to emerge from the
darkness of the right-hand panel is the head of the figure in the background,
Mark. Indeed, he seems to be thrusting himself vehemently forward, a fiery look
in his wide eyes with their dazzling whites, his lips parted as if about to speak,
his eyebrows quivering and his features animated. The foreground of the right-
hand panel belongs to Paul the Apostle. Particularly impressive is the myster-
iously iridescent grey of his heavy mantle with its deep folds, within which
shades of green and blue shimmer. The flashing eye of this spiritual hero forms
as it were the focus of both panels.

In the preface to his ground-breaking German translation of the Bible, Luther
pronounced the Gospel of St John, the Epistles of St Paul and the first Epistles of
John and Peter to be the core of the Scriptures. The close correlation between
these authors and the individuals in the painting is alone enough to suggest that,
with this painted manifesto, Dürer was seeking to interpret Luther's theology of
the Word. This is reinforced by the text copied out in a narrow band across the
bottom by the calligrapher Johann Neudörfer. It cites the four holy men as
authorities who, so the central message implies, serve to warn all worldly rulers
against the abuse of the true faith, against "false prophets". Since the Nuremberg
civic authorities had long since renounced Catholicism and embraced the Pro-
testant confession, and given Dürer's own sympathy for Luther, his reference to
"false prophets" can only mean those radical and iconoclastic tendencies within
Protestantism such as Thomas Müntzer's Anabaptists.

In 1547 Johann Neudörfer recorded that Dürer's *Four Apostles* also illustrated
the four human temperaments or humours, the diagnostic elements of a system
of medicine that went back to antiquity and had gained new currency in the
Renaissance. Thus St John takes the role of the equable sanguine, and the devout,
somewhat corpulent, elderly St Peter that of the phlegmatic; St Mark represents
the choleric and St Paul the melancholic. Dürer's enduring preoccupation with
the four temperaments is also evidenced, for example, by his *Portrait of Johann
Kleberger* (ill. p. 76). The portrait of the dubious parvenu – psychologically the
most scintillating that Dürer ever painted – is like a medallion that has come to
life, surrounded by astrological signs. The sitter's physiognomy, however, as
Dürer portrays it, identifies him as what in those days would have been under-
stood as a "mixed breed" of sanguine and choleric.

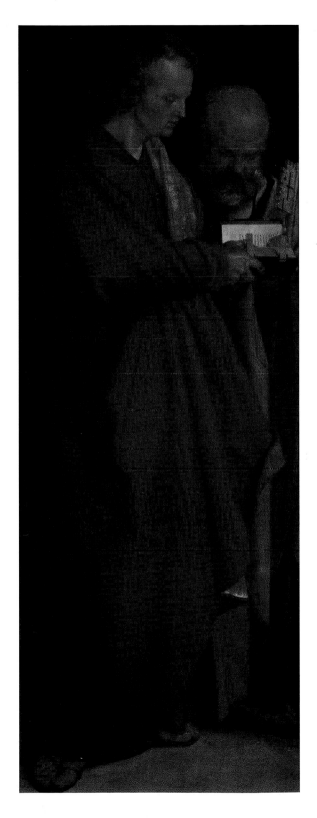

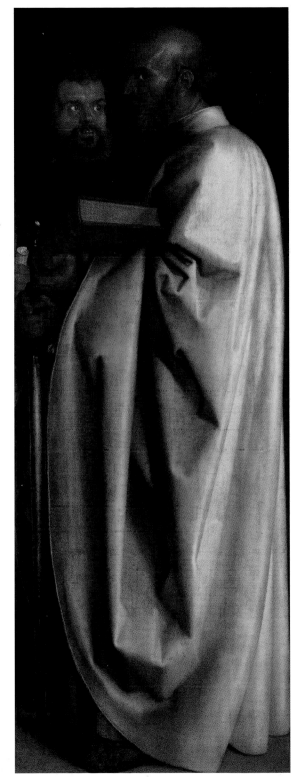

Salvator Mundi, 1504/1505
Mixed media on limewood (unfinished),
58.1 x 47 cm
New York, The Metropolitan Museum of Art
(The Friedsam Collection, Bequest of Michael
Friedsam, 1931)

The origins of this painting, impressive even
in its unfinished state, are unknown. It un-
doubtedly reflects the influence of works by
Jacopo de' Barbari, however.

PAGE 79:
The Virgin Mary in Prayer, 1518
Mixed media on limewood, 53 x 43 cm
Berlin, Staatliche Museen zu Berlin –
Preussischer Kulturbesitz, Gemäldegalerie

The panel is thought to be the right half of a
diptych, whose left half – now lost – depicted
Christ as the Saviour of the World or as a Man
of Sorrows.

Praying Hands, 1508
Brush in grey and black ink, with a grey wash,
heightened with opaque white,
on blue prepared paper, 29.1 x 19.7 cm
Vienna, Graphische Sammlung Albertina

Back to the *Four Apostles*: Dürer thus uses one of the four basic temperaments
of the human soul to individualise each saint. Starting from this viewpoint and
intellectual model, it is perhaps permissible to "reconstruct" the "missing" centre
of the two panels which, as implied earlier, can be visualized in the mind's eye.
According to the theories of the day, the four humours resulted from the pre-
dominance in the body of a particular fluid (blood for the sanguine, phlegm for
the phlegmatic, yellow bile for the choleric, and black bile for the melancholic),
and these four fluids were in turn associated with one of the four elements. Each
temperament thereby represented an "extreme", a state of physiological imba-
lance. On the opposite side of the scales was *eukrasia,* the state of harmonious
balance, also known as the *quinta essentia,* the "fifth essence": a perfect equi-
librium that is the substance of none but the supreme divine principle. Bearing
all this in mind, Dürer's four holy warners against false prophesy, his four holy
incarnations of a "Christian soul", assume their ultimate authority from their
direct association with the Most High, with God: a clear rejection of the "privati-
sation" of saints that Luther so vehemently deplored!

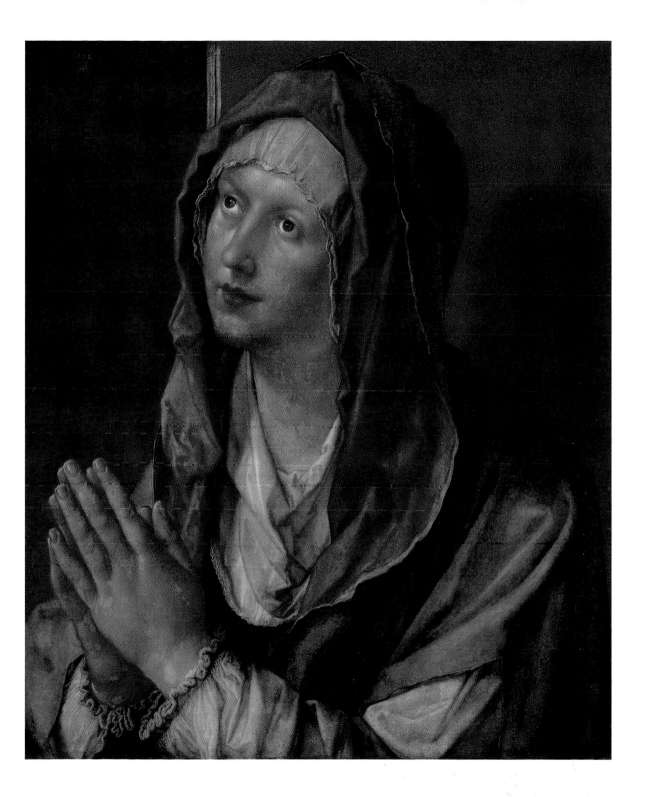

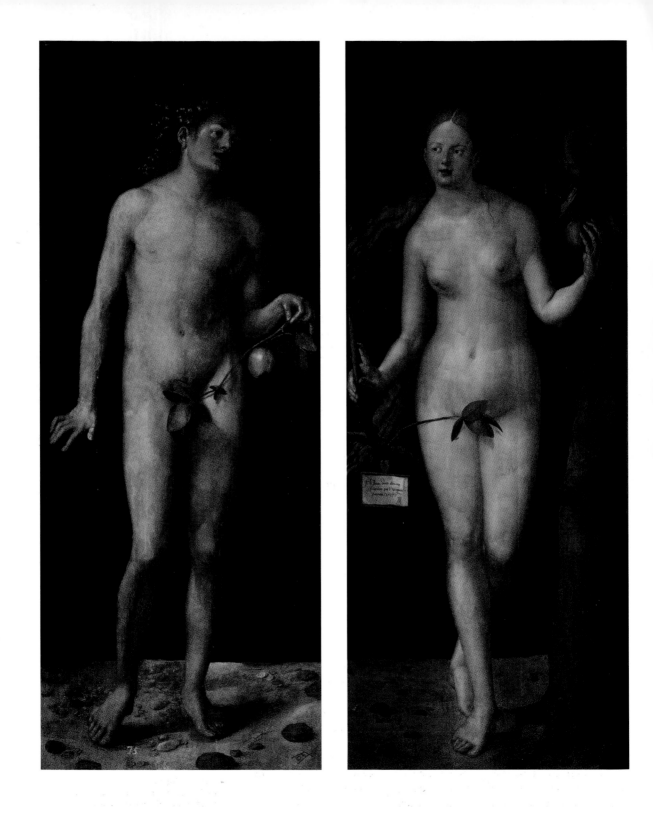

A new Apelles

In 1519 a Dürer medallion was in the making. The artist thereby aligned himself with the small circle of the political and cultural élite to whom this honour was customarily awarded. By becoming one of the first artists north of the Alps to have a portrait medallion made of himself, Dürer played a very deliberate part in ensuring his name would endure for posterity.

Did the Nuremberg master supply the design for the boxwood model himself? It is possible that he sent the medallist Hans Schwarz (1492 – after 1521) a preliminary drawing. But it is equally possible that the striking profile by which Dürer would be instantly recognized by subsequent generations was crafted by Schwarz, an Augsburg sculptor, himself. It was Schwarz, after all, who raised the art of the medallion in Germany to previously unseen heights. The Imperial Diet of 1518 in particular gave him the chance to produce likenesses of several prominent delegates in a number of genres. He certainly had the necessary skill, therefore.

Whatever the case, the Dürer medallion designed in 1519 fully lived up to the title that had been bestowed on Dürer, namely that of "a second Apelles".

The humanist and Latin scholar Konrad Celtis had already described his Nuremberg friend as an *alter Apelles* (a second, new Apelles) shortly before 1500. This superlative comparison between Dürer and Apelles – the painter of antiquity celebrated in classical literature – was also drawn by the artists in Venice and Bologna, according to Christoph Scheurl in 1508. Erasmus of Rotterdam, the most famous universal scholar of his day, praised Dürer in 1526 as the "Apelles of the black line". In the period that followed, the concept of Dürer as the new Apelles made a regular appearance in writings on his art. These all saw the Nuremberg artist as the re-inventor of the art of painting and drawing in the spirit of antiquity: just as the Greek Apelles shone under the reign of Alexander the Great, so did Dürer under Emperor Maximilian!

No great Renaissance artist could be at the pinnacle of his profession without also having an understanding of artistic theory. This was an area that obsessed Dürer like no other, with the exception of Leonardo da Vinci.

Dürer's interest in ideal proportions extended after 1500 to almost every subject. He considered proportion to hold the universal key to form. Even the most ordinary object possesses character, size and shape. High art is born from the field of tension between nature and ideal construct.

Saint Apollonia, 1521
Black chalk on green prepared paper,
41.4 x 28.8 cm
Berlin, Staatliche Museen zu Berlin –
Preussischer Kulturbesitz, Kupferstichkabinett

If we compare this study of a young woman, rendered with masterly modelling, with Dürer's compositional sketch (today in Paris) for his planned picture of the Virgin and Child with saints, we are able to identify her conclusively as St Apollonia.

Adam and Eve, 1507
Mixed media on panel, each 209 x 83 cm
Madrid, Museo Nacional del Prado

Portrait of a Boy with a Beard, 1527
Watercolour on canvas, 55.2 x 27.8 cm
Paris, Musée du Louvre, Cabinet des Dessins

While other instances of miraculous signs and abnormalities documented in Dürer's work find supporting evidence in the broadsheets of his day, this is not the case with the bearded child. Perhaps the artist visualises him not as a prodigy but as a hieroglyphic symbol: the embodiment of the past and future generations in a hybrid of boy and old man.

Adam and Eve, 1504
Copperplate engraving, 25.2 x 19.5 cm
Corte di Mamiano, near Parma, Fondazione Magnani Rocca

According to Panofsky, the various animals gathered around Adam and Eve signify – in line with scholastic theory – the four temperaments which, thrown into disorder by the Fall, will bring sickness and death to humankind in future. This interpretation is today almost unanimously rejected.

Dürer's copperplate engraving of *Adam and Eve* of 1504 (ill. p. 83) represents one of the high points in his efforts to render the human body in its correct proportions. The final composition is based on studies begun in 1500 and generating, over the course of four years, the "perfect man" and the "perfect woman", whose contrapposto is rendered convincingly for the first time in German art. The sum of humanist scholarship that Dürer invested in this composition – he studied amongst other things the rules of Vitruvius (c. 84 – after 27 BC) – might lead us to expect a rather pedantic exercise in artistic theory. But the element of construction is absorbed into the element of atmosphere. For the first time in the history of the printed image, pale bodies stand against a dark background; for the first time in the field of graphic art, the atmospheric potential of the pictorial ground is discovered. Adam and Eve are presented at a moment of tension, of pause, when all is still governed by divine harmony. Immediately before the Fall, Adam and Eve are still ideal images of human beauty – but in a second's time they will face an earthly destiny in bodies burdened with sin and subject to decay. The fact that the Garden of Paradise is already mutating into a dark forest, primitive and uncivilized, already warns of the threatening forces of nature, while the animals it shelters probably refer to humankind's carnal future.

Three years later, Dürer took the same subject yet further in two large panel paintings of Adam and Eve, both of them glittering and indeed pioneering examples of large-format nude painting north of the Alps (ill. p. 80). For whom, for where and indeed why they were painted are questions sadly still unresolved. Dürer succeeds in creating a human couple full of life and beauty, their plasticity heightened by the dark, monochrome background; he succeeds in creating nudes whose sensuality overshadows the proportional calculations that underlie them.

Dürer would only execute one other nude, or "naked picture", as he put it, in the medium of oil on panel (although drawings of the same subject survive in their hundreds): the *Lucretia* in Munich (ill. p. 88). Unlike the paintings of *Adam and Eve,* she has attracted little praise from modern critics. The unequal length of her arms, the almost piercingly upward thrust of her body, the strange tilt of her head with its theatrical expression and the admonition to remain chaste, already implicit in the classical theme but nevertheless given exaggerated emphasis by Dürer, are all disturbing. To make matters worse, the loincloth covering the otherwise naked woman was "expanded upward" in the prudish Catholic Munich of around 1600.

The "German Apelles" embraced the Renaissance ideal of the *artes liberales:* art was no longer the trade of a craftsman, in other words, but a creative achievement built upon scientific and theoretical foundations. The painter and printmaker devoted twenty years to composing a number of instruction manuals on various facets of art theory. It was only after his return from the Netherlands, i.e. after August 1521, that he began to assemble his vast quantities of designs, notes and first drafts for actual printing. His first publication, *Instruction in Measuring with the Compass and Ruler,* appeared on the Nuremberg book market in 1525. Its achievement lay not least in its coining of a new vocabulary to convey technical terms in German (scholars usually wrote in Latin). There were occasions, however, when Pirckheimer – who was editing the treatise – had to step in. Thus he replaced Dürer's choice of "prick" with "private parts", and deleted "arse" in favour of the less vulgar "behind".

In 1522 the German princes set up a commission to discuss defensive measures against the Turks and, even more importantly, the building of fortifications. They employed the advisory services of Dürer. His *Treatise on Fortification*

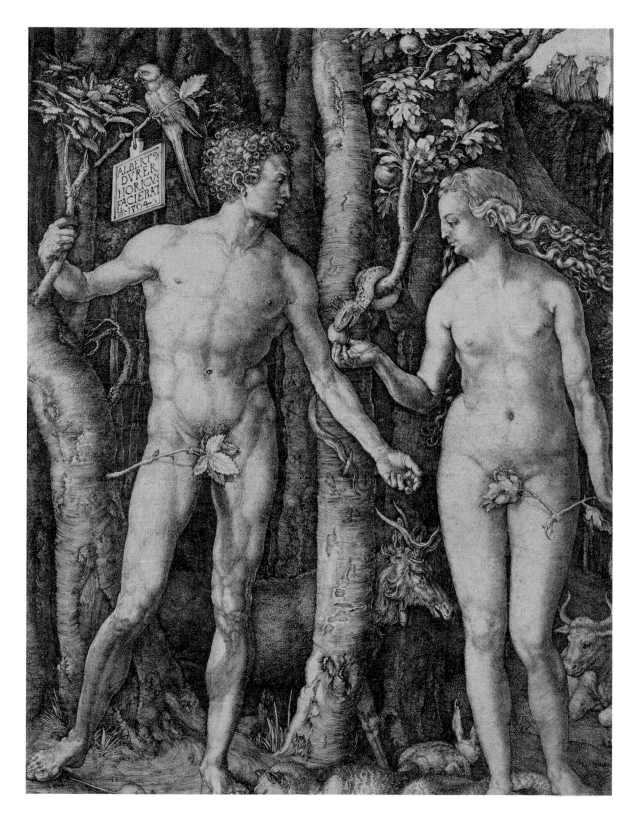

appeared in 1527. At the start of 1528 Dürer succeeded in assembling the first of
his four books on human proportion ready for publication. By the time it went
to press in October 1528, its author was already dead.

Albrecht Dürer's treatise on proportion was far in advance of the time in
which he was living. Insofar as Dürer conceived of figures that could be pro-
duced in any type desired and could also be modified and moved as desired,
whose outlines were mathematically determined and whose interior detail was
to be filled in later, he anticipated – according to the interesting, logically pre-
sented argument of Johann Konrad Eberlein – the methods of digital simulation.
"The assertion of the artist as individual in the Renaissance", the author con-
tinues, "stands in fundamental opposition to the modern era's production of
images by technical means. Dürer came so close in his ideas to the principles
of mass reproduction that no one followed him, because no one was willing to
enter the pact that he proposed with measurement, or to put it in another way,
with technology."

PAGES 86 / 87:

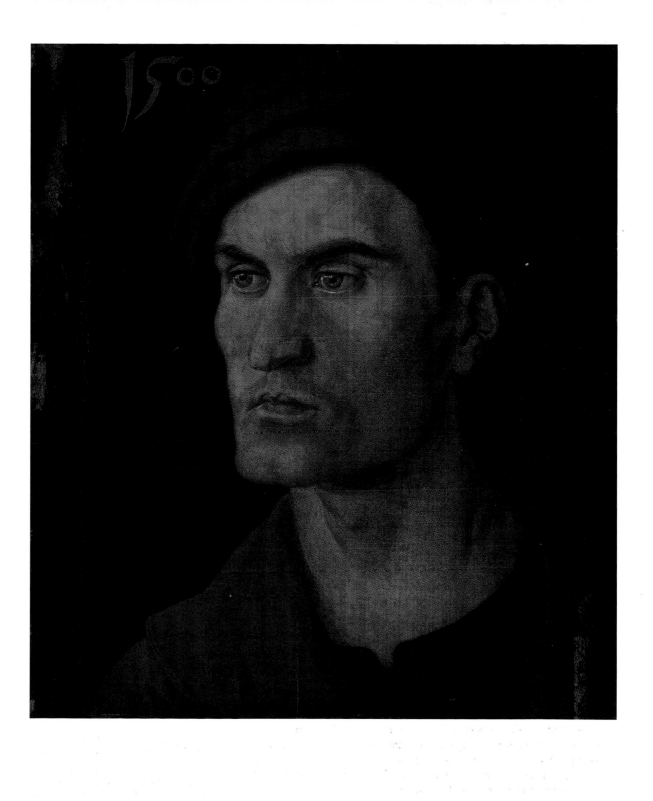

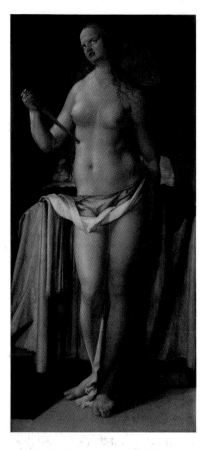

The Suicide of Lucretia, 1518
Mixed media on limewood, 168 x 74.8 cm
Munich, Bayerische Staatsgemäldesammlungen,
Alte Pinakothek

Portrait of Jakob Muffel, 1526
Mixed media on canvas, transferred to panel,
48 x 36 cm
Berlin, Staatliche Museen zu Berlin –
Preussischer Kulturbesitz, Gemäldegalerie

Muffel, who formed part of Dürer's circle of
friends, held a number of senior offices in
Nuremberg. Since Muffel died in April 1526,
this portrait must have been completed earlier
that same spring.

Dürer also fulfilled another typical ideal of his day, that of versatility. We have already seen that he was active in the domain of sculpture. Even if his involvement on Maximilian's tomb in Innsbruck (cf. ill. p. 94) was only indirect, via designs, the small relief in Solnhofer stone of a standing female nude seen from behind (New York, The Metropolitan Museum of Art) may be the direct product of Dürer's own hands.

In 1510 Dürer supplied designs for epitaphs for the Fugger funerary chapel constructed between 1509 and 1518 in St Anne's church in Augsburg. The Fugger chapel occupied its own chancel, in the Venetian manner, and it is possible that this unique jewel of Central European Early Renaissance architecture was designed by a Venetian. Good arguments also exist, however, to support the thesis that the actual author was Dürer, which would prove him a dazzling architect. The Nuremberg artist certainly designed a house in Mechlin for the physician to the general governor of the Netherlands, Arch-Duchess Margaret, as he mentions almost incidentally in the diary he kept of his Netherlands trip.

Dürer's attempts at poetry and music deserve only a brief mention since he never achieved more than amateur status in either. That his activities as an artist extended to numerous drawings and watercolours for costume studies, however, as well as a book on fencing, should be underlined. Universality in every respect!

Albrecht Dürer died on 6 April 1528 of the consequences of malaria, "as withered as a bundle of straw" (Pirckheimer). His body was buried beneath a simple bronze tablet in the Johannisfriedhof cemetery. Pirckheimer composed the immortal epitaph: *Quicquid Alberti Dureri mortale fuit, sub hoc conditur tumulo* (Whatever was mortal of Albrecht Dürer lies beneath this mound). There does not appear to have been an official funeral. Dürer left his wife a fortune of almost 7000 guilders, placing him amongst the one hundred richest burghers in Nuremberg.

It is alleged that friends of the artist secretly exhumed the body a few days after the burial and made plaster casts of his face and hand. The lock of hair (ill. p. 95) cut from Dürer's head while he still lay on his deathbed was taken to Strasburg, somewhat like a relic, by Dürer's pupil Hans Baldung Grien. It would become an object of veneration for future generations and is today housed in the Academy in Vienna. Dürer's death mask appears to have been destroyed in the fire of 1729 that ravaged the Residence in Munich. Dürer's bones were lost when the cemetery was dug over in 1550.

The loss did nothing to halt the process of what may be called "Dürer worship", which had begun in no small measure even during the artist's own lifetime. No other figure in the history of German art has enjoyed such legendary status over the centuries – and not just in Germany.

When, in Florence around 1560, the Grand Duke of Tuscany Cosimo I decided to create a collection of portraits of famous contemporaries and the best artists, "Alberto Durero" was the only foreign painter to be honoured with a portrait and accepted into the pantheon alongside Leonardo, Titian and Michelangelo.

The years around 1600 saw a positive Dürer Renaissance, in particular at the courts in Prague and Munich. But not only there: in 1604 the erudite Hamburg book dealer Georg Ludwig Frobenius (1566 – 1645) gave a number of sheets supposedly by Dürer the title of "Icones Sacrae" (sacred pictures). He thus placed them on a par with religious icons. Works of art by Dürer were at that time granted almost the same respect as holy relics. There was a reason for this, and it can be traced back to the Counter-Reformational edicts of the Council of Trent (1545 – 1563).

Head of a Young Woman, 1506
Brush and grey ink, heightened with opaque
white, on blue paper, 28.5 x 19 cm
Vienna, Graphische Sammlung Albertina

The artistic technique and the blue paper
are typical of the brush drawings that Dürer
executed during and immediately after his
second trip to Venice.

Portrait of Hieronymus Holzschuher, 1526
Mixed media on limewood, 51 x 37 cm
Berlin, Staatliche Museen zu Berlin –
Preussischer Kulturbesitz, Gemäldegalerie

This imposing likeness of a member of one
of Nuremberg's patrician families enjoys par-
ticular fame amongst Dürer's late portraits.
Holzschuher, who had studied in Italy, had been
a member of the city council since 1499 and was
a supporter of the Reformation in Nuremberg.

The Council of Trent proclaimed two artists as examples of truly "virtuous" painting: the Italian Cimabue (c. 1240 – 1302) and the German Dürer. Dürer, who was in fact anything but an arch-Catholic, was held up as the "virtuous hero" of the North. Both were credited with achieving a sacred dignity in their art. In 1582, some twenty years after the council, the archbishop of Bologna, Cardinal Gabriele Paleotti, entitled a chapter of his treatise on sacred and profane art "Examples of a number of painters, sculptors and other artists who are numbered amongst the saints [!] or who are held in high esteem on account of their excellent and exemplary lives." Last to be held up is Dürer, whose œuvre – we are told – bears clear witness to his close adherence to a saintly and dignified path.

On the streets of German cities around 1800, it was not uncommon to see young men dressed and coiffured *á la* Dürer (as he appears in his Munich self-portrait). Romantic novels cast the painter from Nuremberg as the champion of an enlightened medieval ideology. For the Nazarenes, a group of German painters in Rome specialising in religious art, Dürer provided a model comparable only to Raphael. In 1815 one of their studio celebrations became a Dürer festival. In 1816 the Albrecht Dürer Association was founded in Nuremberg. The years after 1830 even saw a flourishing trade in Dürer kitsch: pipe bowls, beer mugs and even lebkuchen biscuits bearing the artist's likeness were all produced on a large scale.

The patriotic excesses that accompanied the outbreak of the Franco-Prussian War in 1870 / 71 sought to make of Dürer the "ultimate German", who – like Charlemagne, Luther, Goethe, Beethoven and Bismarck – would represent Germanness as Providence. When, in 1902, Ferdinand Avenarius founded the Dürerbund association for the promotion of a "healthy" art, and when Julius Langbehn and Momme Nissen wrote a booklet bearing the title *Dürer as Leader* in 1904, they paved the way for the Nazi ideology that would take in both Dürer and Nuremberg. It was no coincidence that the National Socialists staged their party congresses from 1933 onwards in the "most German of all cities" (Hitler). In an imperial city which was, moreover, the home of the "most German of all German artists".

To allow such perverted voices the last word on Dürer would be tantamount to a perversion itself. No, the final say shall go to a work, one of his last and one of his most grandiose.

Once again it is a portrait, one that captivates us with the vehemence of its humanist aesthetic. In 1526 Dürer painted the Nuremberg patrician Hieronymus Holzschuher (ill. p. 91). The powerful head of the 57-year-old fills almost the entire panel. The upper body, draped in a heavy fur, seems to serve solely as a plinth for the head and face, which brims with fierce self-assurance. The incredible keenness with which Dürer examines every phenomenon, every sign of life, is not simply lost in details, but is subordinated to the powerful modelling of the face and the energetic presence of the sitter, who announces himself as an individual as much as a person of rank. The window bars reflected in his pupils are those of the same room in which the painter is carrying out the task of visualisation. In addition to capturing a likeness of his sitter, however, Dürer is also attempting to portray his character type, in line with the contemporary theory of the four humours. Nature and ideal combined! The Renaissance understanding of man and the world has found its way into German painting through the kindred vision of Albrecht Dürer.

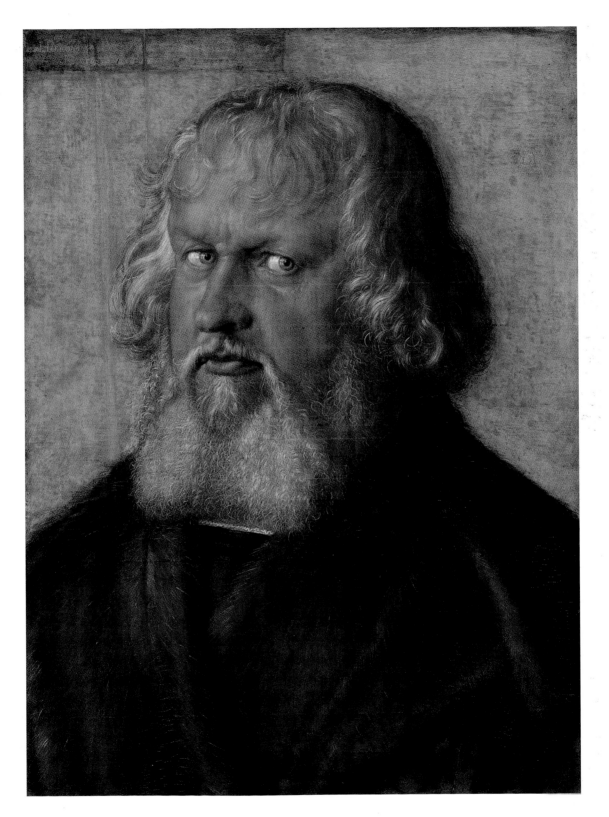

Albrecht Dürer 1471–1528
Chronology

1471 Albrecht Dürer is born on 21 May in Nuremberg. He is the third child of goldsmith Albrecht Dürer the Elder (1427–1502), who left Hungary to settle in the Free Imperial City on the River Pegnitz in 1444, and his wife Barbara, née Holper (1452–1514).

1481–1485 In 1481/82 the young Albrecht begins a formal education (probably at a school for rudimentary reading, writing and arithmetic), where he may also have learnt a little Latin. In 1484/85 he joins his father's goldsmith's workshop. There, in 1484, the thirteen-year-old produces the famous silverpoint drawing in which he captures his own likeness. Perhaps this is also a sort of message to his father that he does not wish to follow in his professional footsteps, but become an artist.

1486 In the same year that the future Emperor Maximilian I ascends the royal throne of the Holy Roman Empire, Dürer (on 30 November) begins his artistic career as an apprentice in the Nuremberg workshop of Michael Wolgemut, where, as he later records, he is somewhat picked on by his colleagues. His apprenticeship comes to an end on 30 November 1489.

1490–1494 Dürer begins his years as a journeyman by setting off for the Upper Rhine, where he wants to visit Martin Schongauer in Colmar. He arrives there somewhere between autumn 1491 and spring 1492. Schongauer dies on 2 February 1491, but his brothers give the visitor from Nuremberg a warm welcome and probably also allow him to study the works that the master has left behind. Where Dürer may have stopped prior to reaching Colmar is uncertain. From the Alsace, his travels take him to Basle, where he works on woodcuts for books. Probably in autumn 1493, he continues on to Strasburg. Here he remains for the first few months of 1494 and paints the *Self-portrait* today housed in the Louvre.

1494 On 18 May Dürer returns to Nuremberg and on 7 July marries Agnes Frey. For reasons unknown, the marriage will remain childless. Agnes has been dismissed by posterity as plain, cantankerous and money-grubbing, but more recently her role within the marriage has been interpreted more positively as business-minded and careful, even if rather naïve.

1494–1500 In autumn 1494 Dürer sets off on his first trip to Italy. His route

Albrecht Dürer as a sixteen-year-old. Detail from:
Meister des Augustiner-Altars
St. Vitus heals a person possessed, c. 1490
Fixed wing from the high altar of Nuremberg's Augustinian church
Nuremberg, Germanisches Nationalmuseum

takes him via Innsbruck and the southern Tyrol most probably to Venice. He returns home in spring 1495. Along the way he produces numerous landscape watercolours. In Nuremberg the friendship develops between the artist and the patrician Willibald Pirckheimer, resulting in Dürer's first commissions for paintings. He also executes his first copperplate engravings. In 1497 he adopts the monogram "AD". 1498 brings further major successes: Dürer is granted membership of the *Herrentrinkstube,* the "Gentleman's Taproom", an exclusive club for patricians. He also paints his Madrid *Self-portrait* and starts on the *Apocalypse,* a series of woodcuts that will bring him international fame. It will be followed by further major series of woodcuts and engravings. Jacopo de' Barbari appears in Nuremberg in 1500 as imperial court artist. Dürer begins studying the theory of proportion and paints his famous *Self-portrait* (Munich, Alte Pinakothek).

1501–1504 Dürer produces his most famous studies of nature, including the *Hare* and the *Large Piece of Turf,* as

Joint coat of arms of the Dürer-Holper families, 1490
Mixed media on panel, 47.5 x 39.5 cm.
Reverse of the Uffizi portrait of the artist's father (ill. p. 7).

The doors featured in this figurative coat of arms refer to the family's origins from the village of Ajtós, which in Hungarian means "door" (in German: *Tür*). Dürer – also written Dürrer, Türer, Thürer and Thurer in the old-fashion spelling – thus means "one born in Ajtós".

Dürer's house at the Tiergärtnertor in Nuremberg, which he bought in 1509.

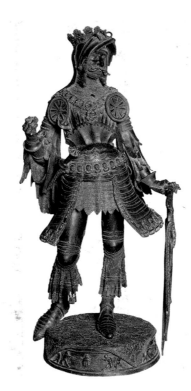

Count Albrecht of Habsburg,
between 1508 and 1518 (design by Dürer,
1513/14; preliminary modelling and casting
by Hans Leinberger in Landshut, probably
1515/16; final casting by Stefan Godl, probably
with Leinberger present, in Innsbruck, 1517/18)
Bronze statue from the cenotaph of Emperor
Maximilian I, height 2.3 m
Innsbruck, Hofkirche

Michael Wolgemut,
Wilhelm Pleydenwurff and workshop
The City of Nuremberg, from the
Schedelsche Weltchronik, 1493
Woodcut, coloured

well as the copperplate engraving of
Adam and Eve based on an intensive
study of human proportion. Following
the death of his father on 20 September 1502, Albrecht takes his mother
and brother into his household.

1505 – 1507 Dürer travels to Italy for
the second time. Amongst the works
he executes in Venice are his magnificent *Feast of the Rose Garlands* altarpiece and his painting of *Christ among
the Doctors,* both completed in 1506.
In February 1507 Dürer returns to
Nuremberg.

1508 – 1511 At the start of this period,
Dürer accepts a commission from an
important Frankfurt merchant for the
monumental *Heller Altar.* One year
later he purchases the house in Zisselgasse that, as "Dürer's house", will become a centre of pilgrimage in the 19th
century and which remains one of

Nuremberg's tourist attractions even today. In 1510 Dürer designs epitaphs for the Fugger chapel in Augsburg. Further major works from this period include *The Martyrdom of the Ten Thousand* (1508) and the *Landauer Altar* (1511).

1512–1518 From 1512 the Nuremberg artist is in the employ of Emperor Maximilian I, who in 1515 awards him an annual stipend for his services. Dürer's beloved mother dies on 6 May 1514. 1513–1514 sees the execution of his three world-famous "master engravings". At the Augsburg Diet of 1518, the "German Apelles" has the opportunity to execute portraits of numerous prominent individuals, not least the Emperor. Whether Dürer makes the personal acquaintance this year of Martin Luther, who will later always speak so admiringly of him, is open to question.

1519 Dürer travels across Switzerland in the company of Pirckheimer and Anton Tucher. He perhaps meets the reformer Ulrich Zwingli on this trip.

1520 Dürer, who has meanwhile become a supporter of Luther and the Reformation, sets off for the Netherlands with his wife Agnes and maid Susanna (travelling via Bamberg, Mainz, Frankfurt and Cologne; on 23 October 1520 he is present at the coronation of Emperor Charles V in Aachen), in order to ask Maximilian I's successor to continue paying his annuity. In Antwerp he executes one of his most celebrated paintings, *Saint Jerome*. In Flanders and Brabant, people fall over themselves to pay homage to the Nuremberg artist. At the end of November 1520, Dürer contracts an insidious malarial infection.

1521 After being misinformed of the death of Luther and composing a

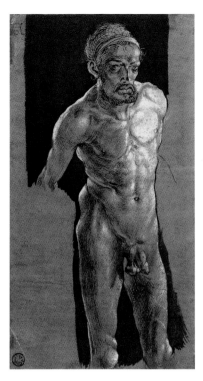

moving lament to his memory, Dürer returns to Nuremberg at the end of July.

1526 The impressive *Four Apostles* are finished.

1528 On 6 April Dürer dies a wealthy man and is buried in the Johannisfriedhof cemetery in Nuremberg.

1539 Death of Agnes Dürer.

1564 With the death of a final distant relation, the Dürer family becomes extinct.

Nude Self-portrait, 1500–1505
Pen and brush in black ink, heightened with opaque white, on green prepared paper, 29.1 x 15.3 cm
Weimar, Stiftung Weimarer Klassik und Kunstsammlungen, Schlossmuseum, Graphische Sammlung

The true purpose behind this enigmatic drawing remains uncertain. To interpret it as a Man of Sorrows, a flagellated Christ bound to a pillar or an experiment in human proportion does not seem to fit its profoundly penetrating and merciless self-interrogation, which has prompted many art historians to draw comparisons with Egon Schiele's Expressionist self-portraits of the early 20th century.

A lock of Dürer's hair
Vienna, Akademie der bildenden Künste, Kupferstichkabinett

Photo Credits

The publishers wish to thank the museums, private collections, archives, galleries and photographers who granted permission to reproduce works and gave support in the making of the book. In addition to the collections and museums named in the picture captions, we wish to credit the following:

© Archiv für Kunst und Geschichte, Berlin: 27, 48, 55 bottom, 93 bottom; © Artothek, Weilheim: 69, 70, 88; © Artothek – Alinari 2006: 59; © Artothek – Joachim Blauel: 38, 64 centre, 66/67; © Artothek – Blauel/Gnamm: 6, 31, 85, 86/87; © Artothek – Ursula Edelmann: 72; © Artothek – Paolo Tosi: 7, 63; © Artothek – G. Westermann: 23 top, 71; © Bildarchiv Preussischer Kulturbesitz, Berlin 2006 – Jörg P. Anders: 9, 20, 22, 30, 34, 39, 51, 76, 81, 84, 89, 91; © Kunst-halle Bremen: 23 bottom; © Staatliche Kunstsammlungen Dresden, Gemäldegalerie Alte Meister – Hans-Peter Klut, Dresden: 57, 64; © Universitätsbibliothek Erlangen-Nürnberg: 1; © 1990, Foto Scala, Florence: 16, 53, 62; © 1999, Foto Scala, Florence: 17, 83; © 1990, Foto Scala, Florence – su concessione Ministero Beni e Attività Culturali: 24, 37 right, 60, 93 top; © Historisches Museum Frankfurt am Main, Photograph Horst Ziegenfuss: 73; © Tiroler Volkskunstmuseum Innsbruck: 94 top; © Staatliche Kunsthalle Karlsruhe: 28, 29; © Staatliche Museen Kassel, Gemäldegalerie Alte Meister: 49; © Instituto Português de Museus, Lisbon, photo José Pessoa: 52; © Copyright the Trustees of The British Museum London: 32; © The National Gallery London: 11, 14, 15; Derechos reservados © Museo Na-cional del Prado, Madrid: jacket-rear, 2, 56, 80; © Museo Thyssen-Bornemisza, Madrid: 33; Photograph © 1989 The Metropolitan Museum of Art, New York: 58; Photograph © 2003 The Metropolitan Museum of Art, New York: 78 top; © Germanisches Nationalmuseum Nürnberg: 10, 12, 45, 68; © Photo RMN, Paris – Arnaudet: 26; © Photo RMN, Paris – Michèle Bellot: 21, 54, 82; © Photo RMN, Paris – R. G. Ojeda: 13; © Board of Trustees, National Gallery of Art, Washington: 18 (Photo by Richard Carafelli), 75; © Stiftung Weimarer Klassik und Kunstsammlungen, Weimar: 95 top; © Albertina, Vienna: 8, 40 top, 40 bottom, 41, 44, 46/47, 47 top, 55 top, 74, 78 bottom, 90, 95 bottom; © Kunsthistorisches Museum Wien: jacket-front, 19, 25, 35, 36, 37 left, 42, 61, 65, 68 centre, 76